SEEN FROM HERE

A photographic-literary encounter with buildings by Aebi & Vincent Architekten

With texts by Gianna Molinari and photographs by Adrian Scheidegger and Alexander Jaquemet

Scheidegger & Spiess

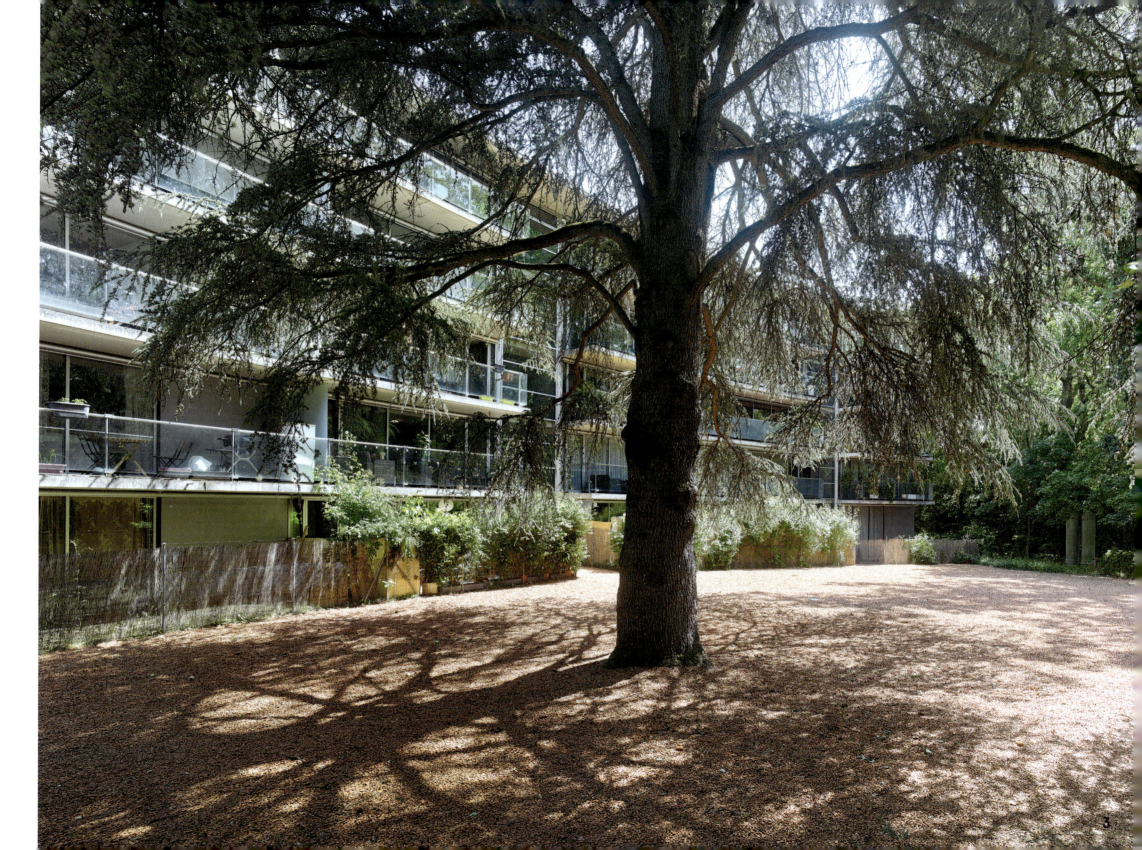

Trampoline And at night foxes frolic on the giant trampoline,
on which children bounce during the day.
While the children sleep beneath down duvets.

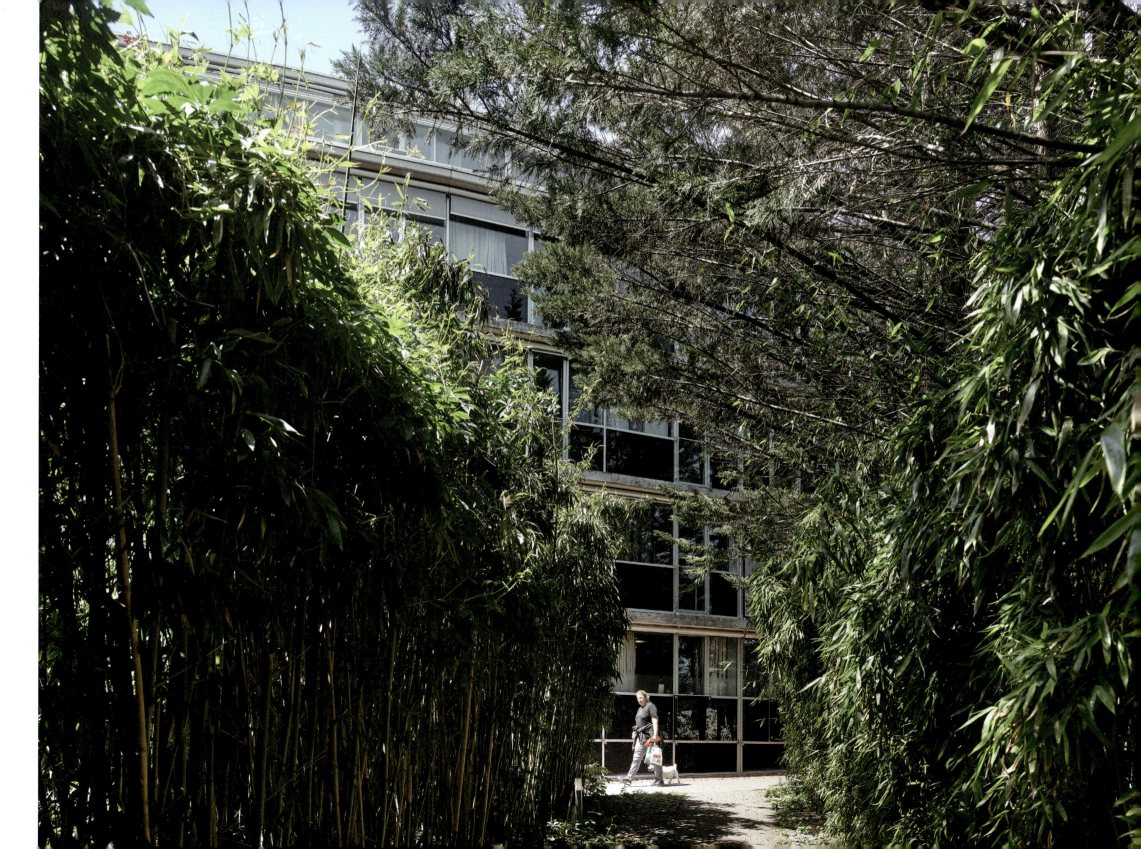

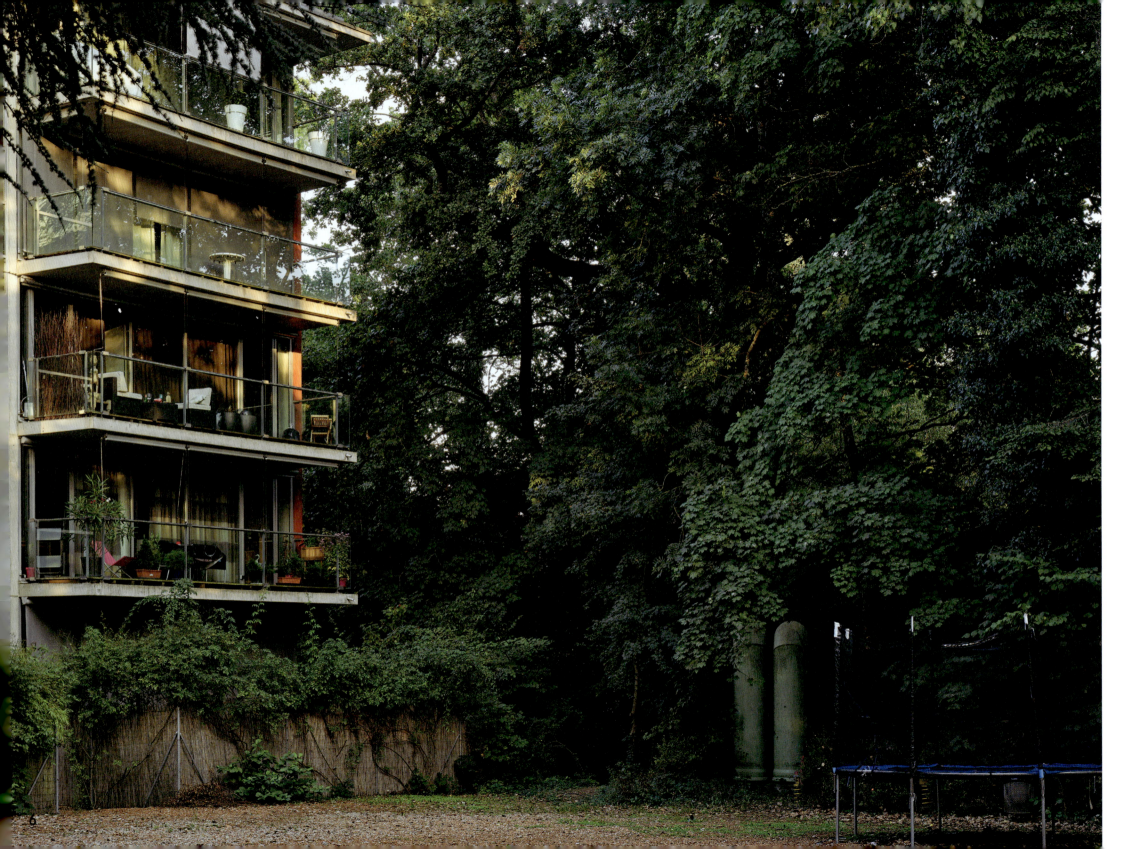

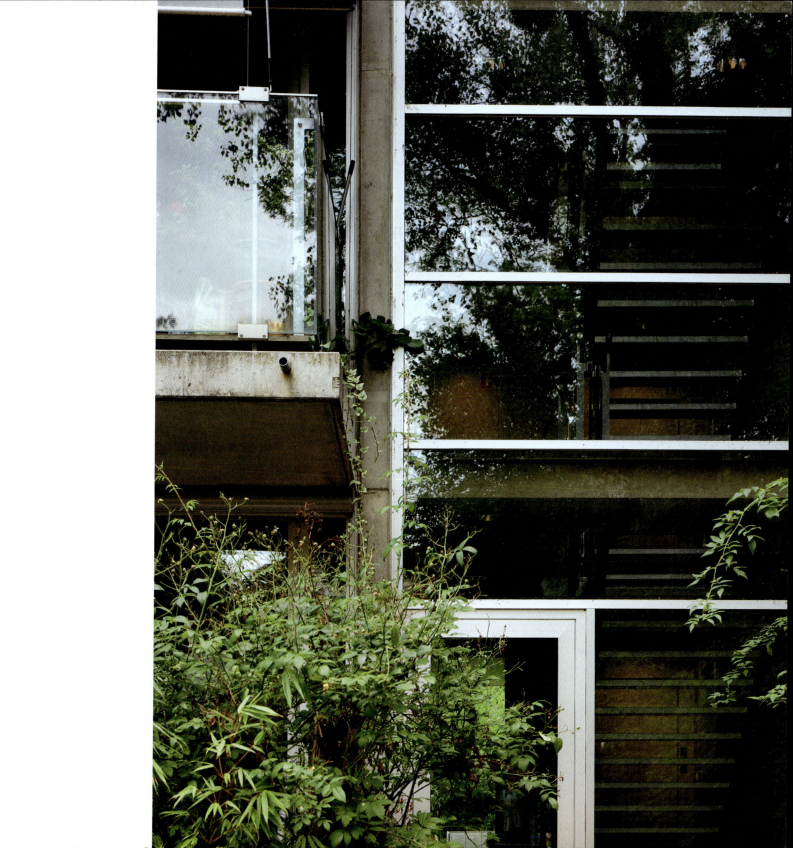

Crack The lake lies in the windowpane. Across the windowpane, gliding smoothly, rowers in the early morning light pull their dead-straight course.
The pulling of the oars through water.
And the windowpane keeps unbroken pace. This amazes him every morning anew. Because he often dreams of a crack in this pane. Because of being under too much tension or the wind coming from the lake, or because of the branch of a tree.
And every time he finds the windowpane in the morning without a crack, he always breathes a sigh of relief and has the feeling that things could somehow work out, that things could turn out well, somehow.

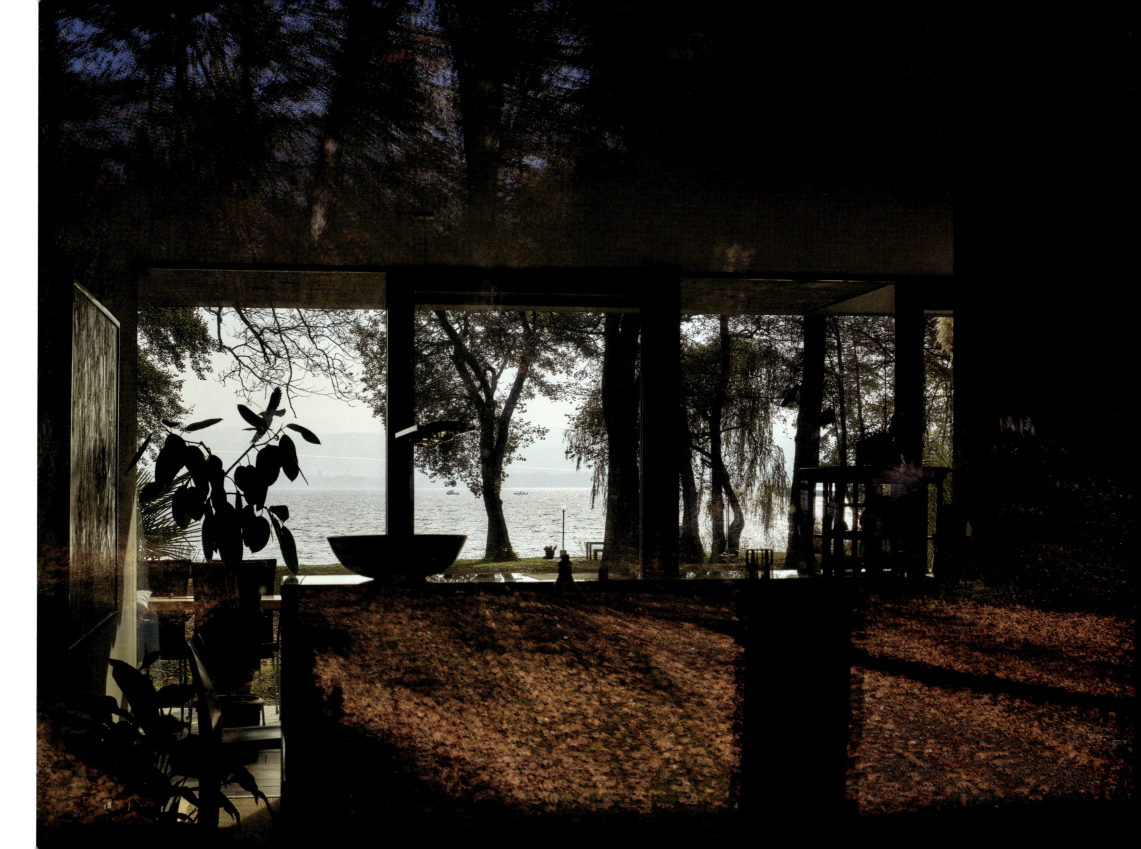

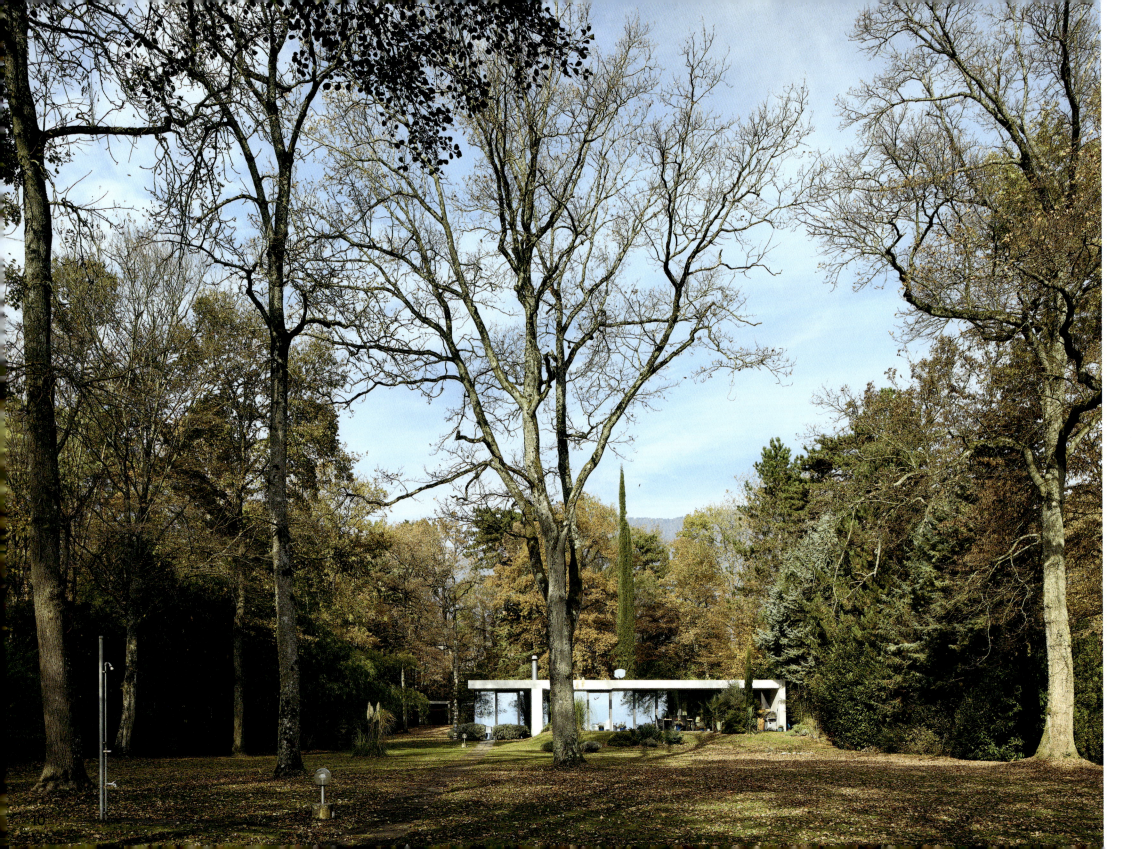

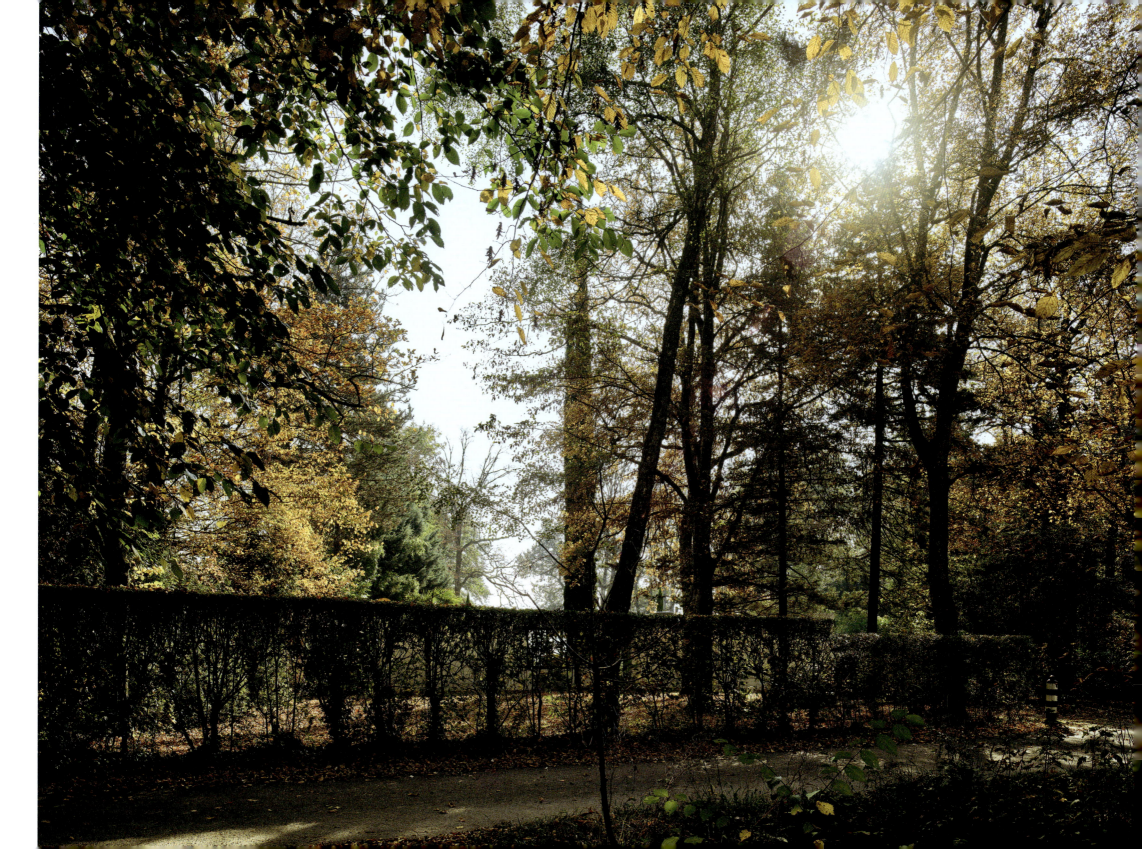

Weekend And parents with children in pushchairs and children with pushchairs go as fast as possible, but slowly through the slow zone, and enter the park.

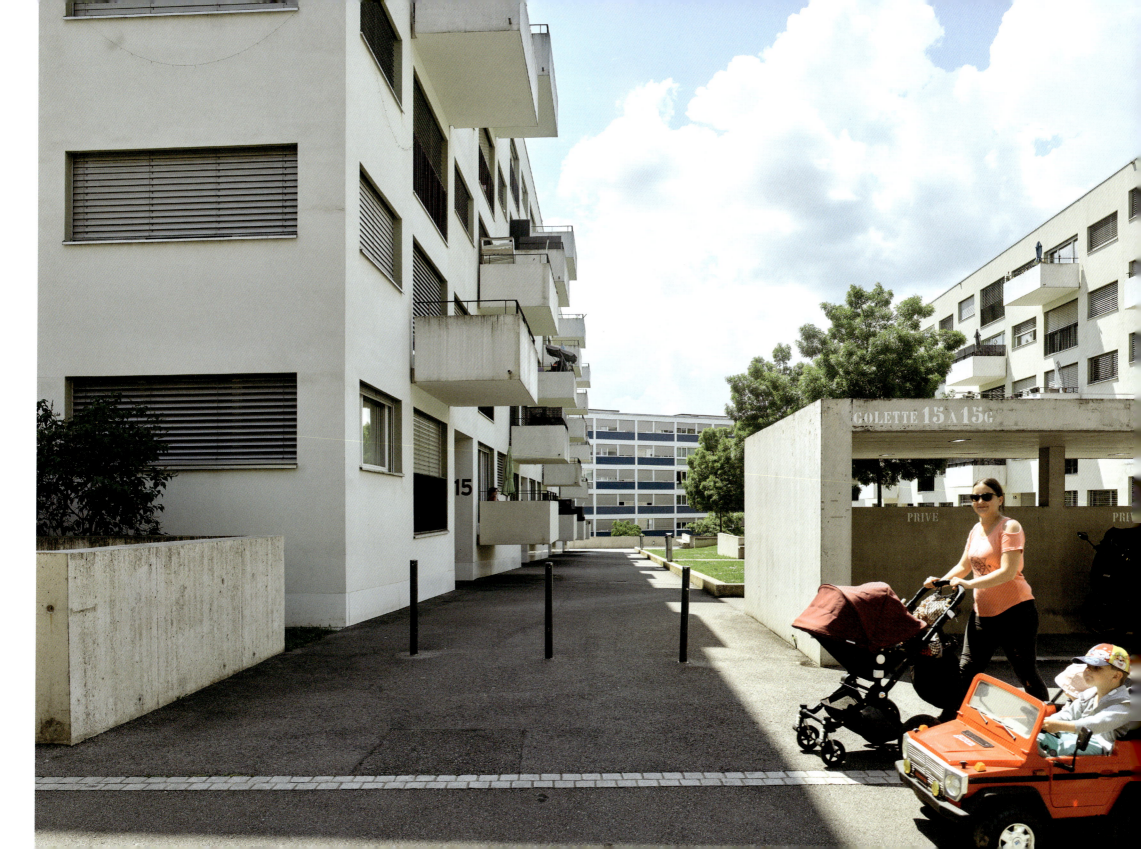

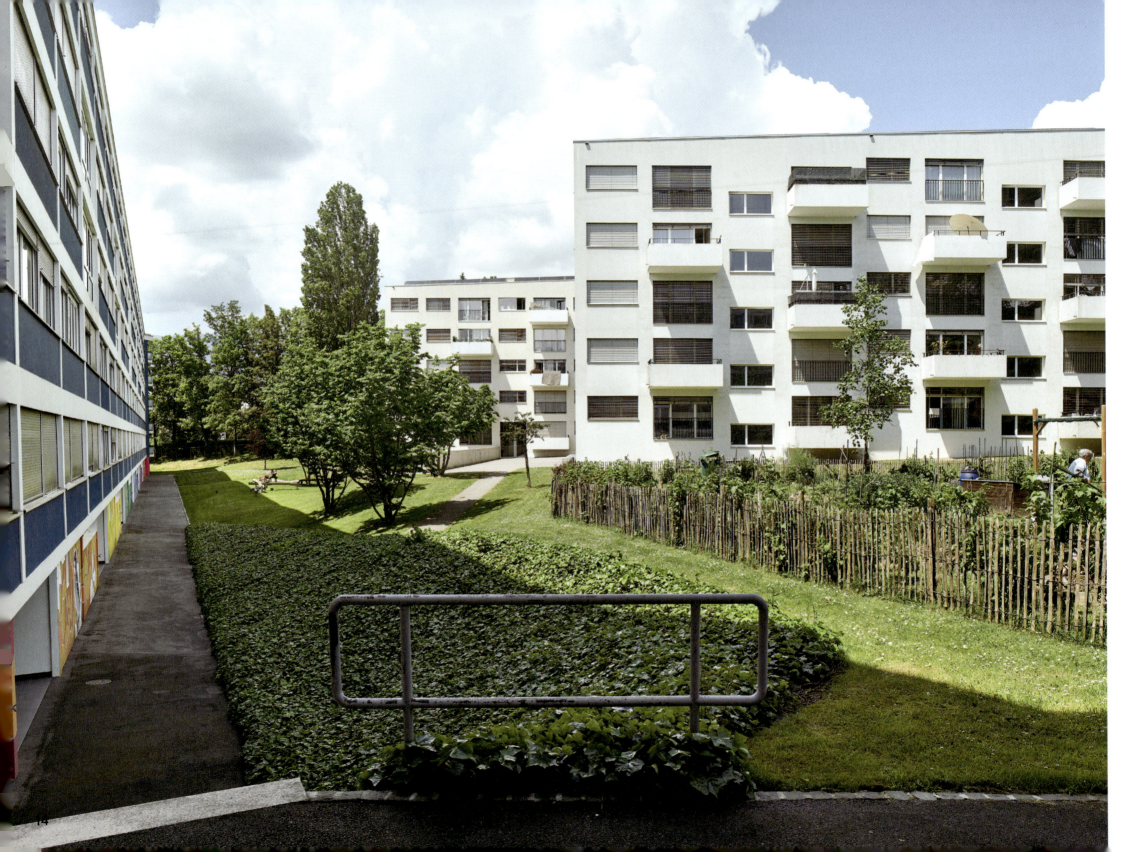

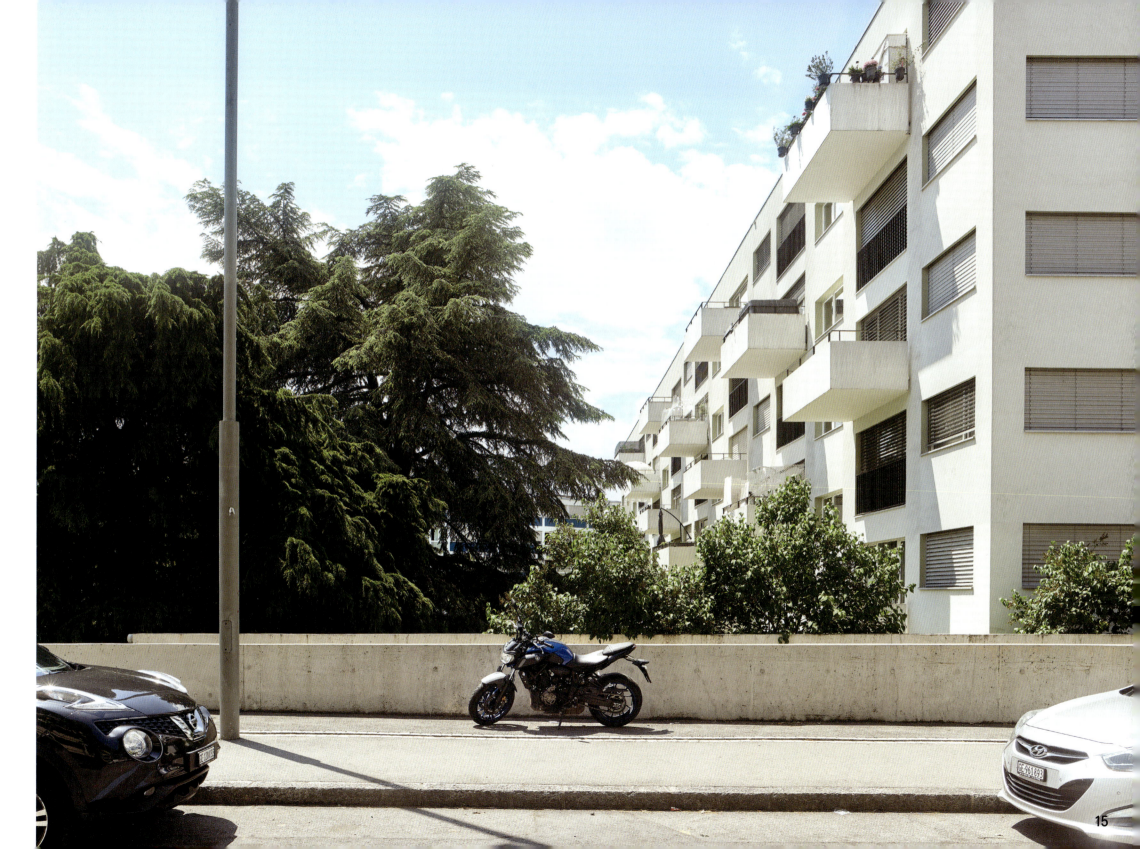

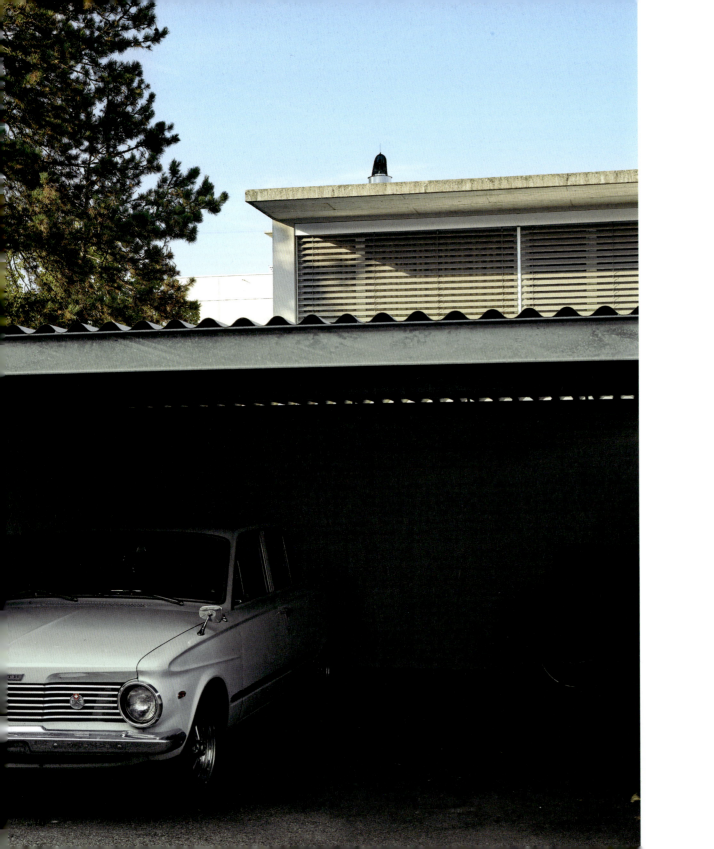

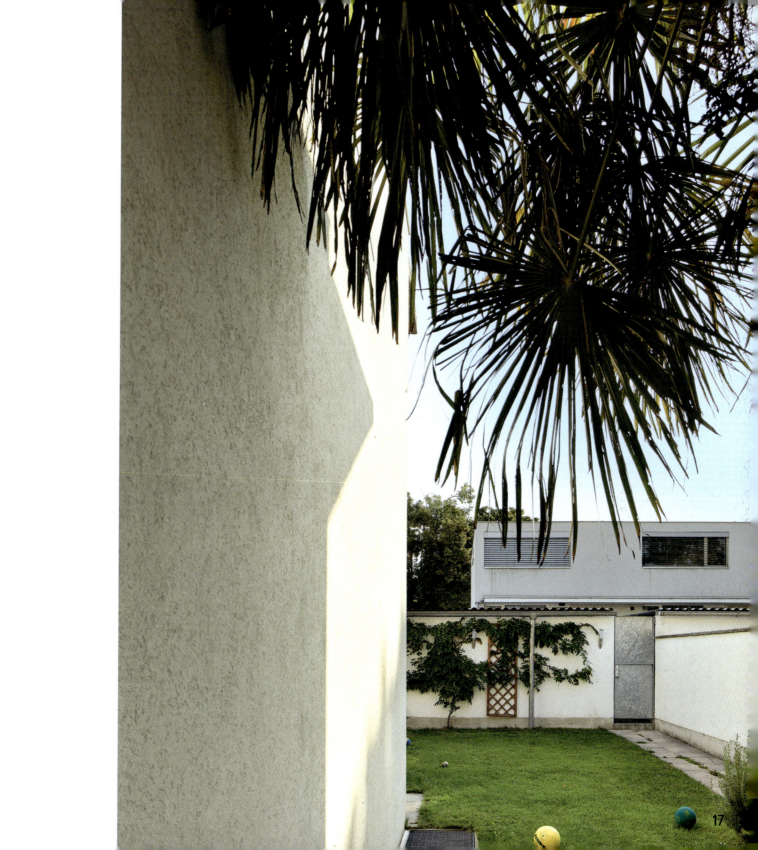

Outside The hedge stops short.
The grass outgrows itself.
And the palm dreams of the south.

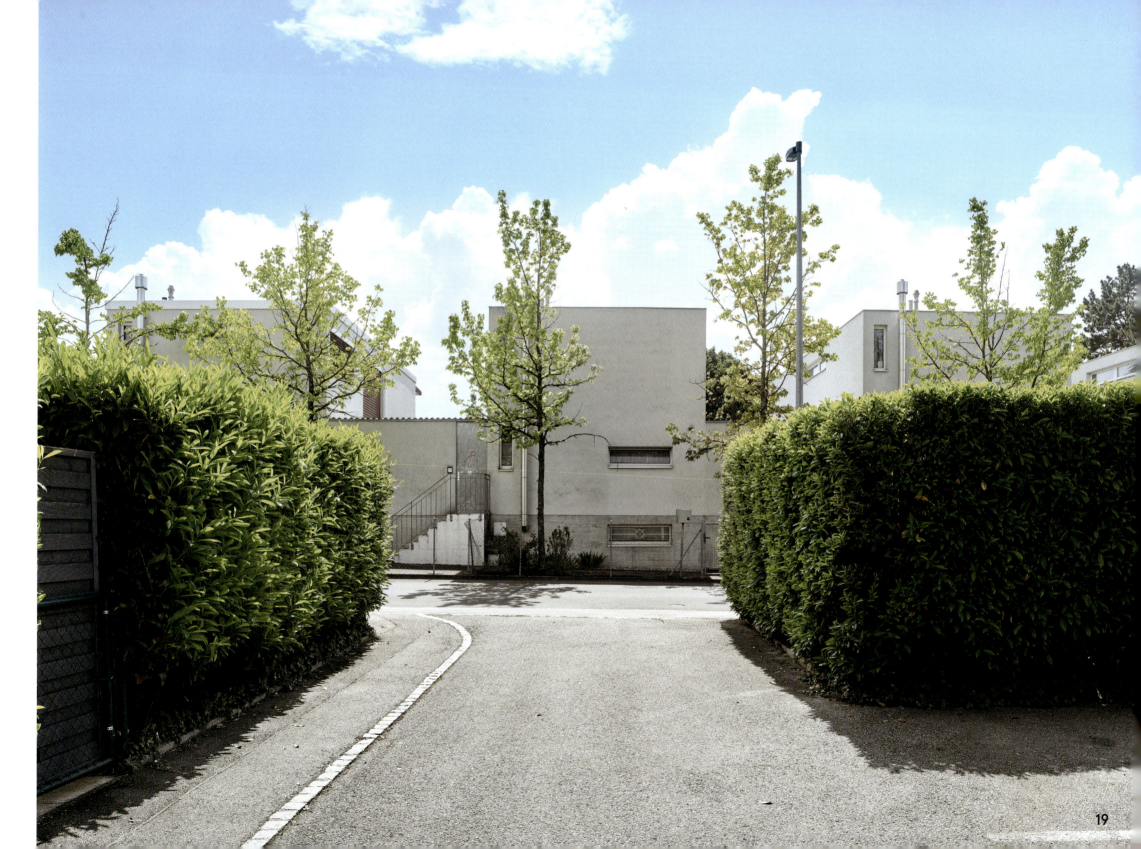

Now and then She'd notice it in the fact that she no longer fitted through the doors quite so easily. Now and then she'd have to pull her stomach in and really squeeze herself through. In truth, she needed to pull her stomach in all the time. She'd notice it in the fact that she bulged out of the windows. One morning, when she woke up, her entire leg was hanging out onto the street. Of course, she quickly pulled it back in as best she could. And she hoped the whole neighbourhood hadn't spotted that she was increasingly growing out of her apartment.

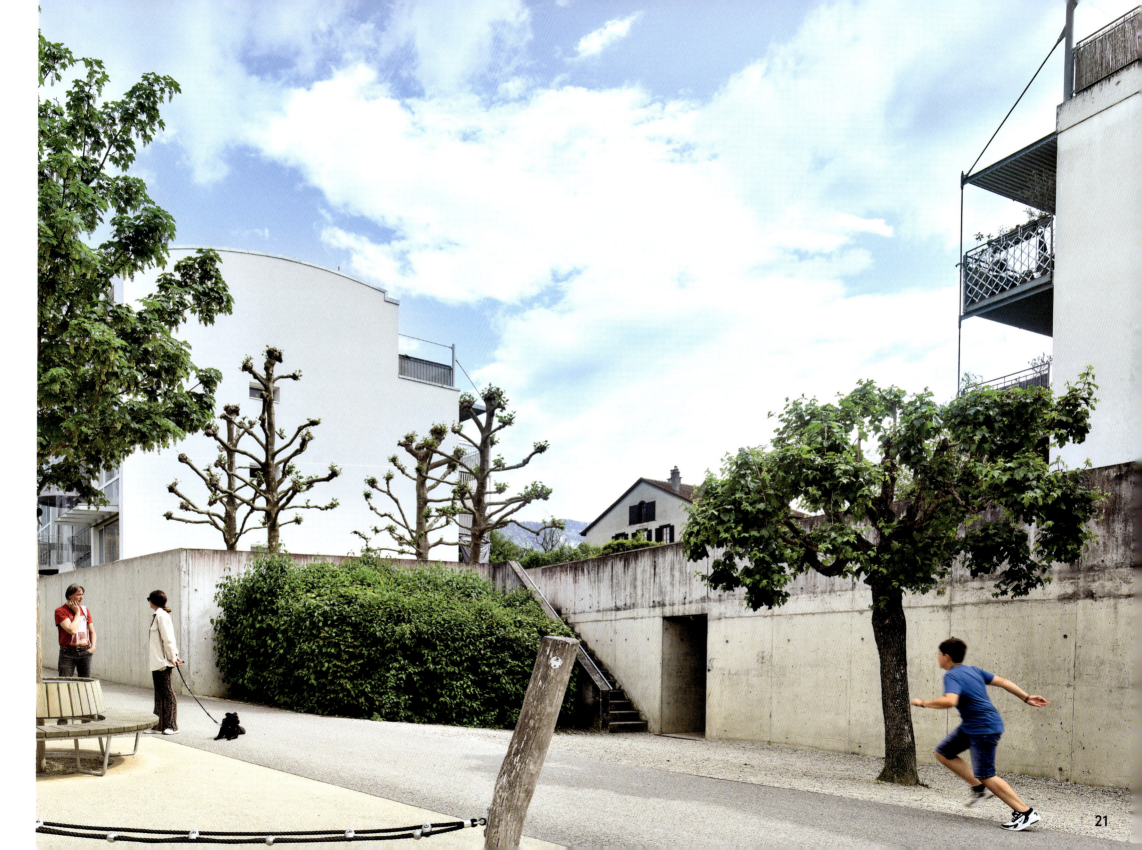

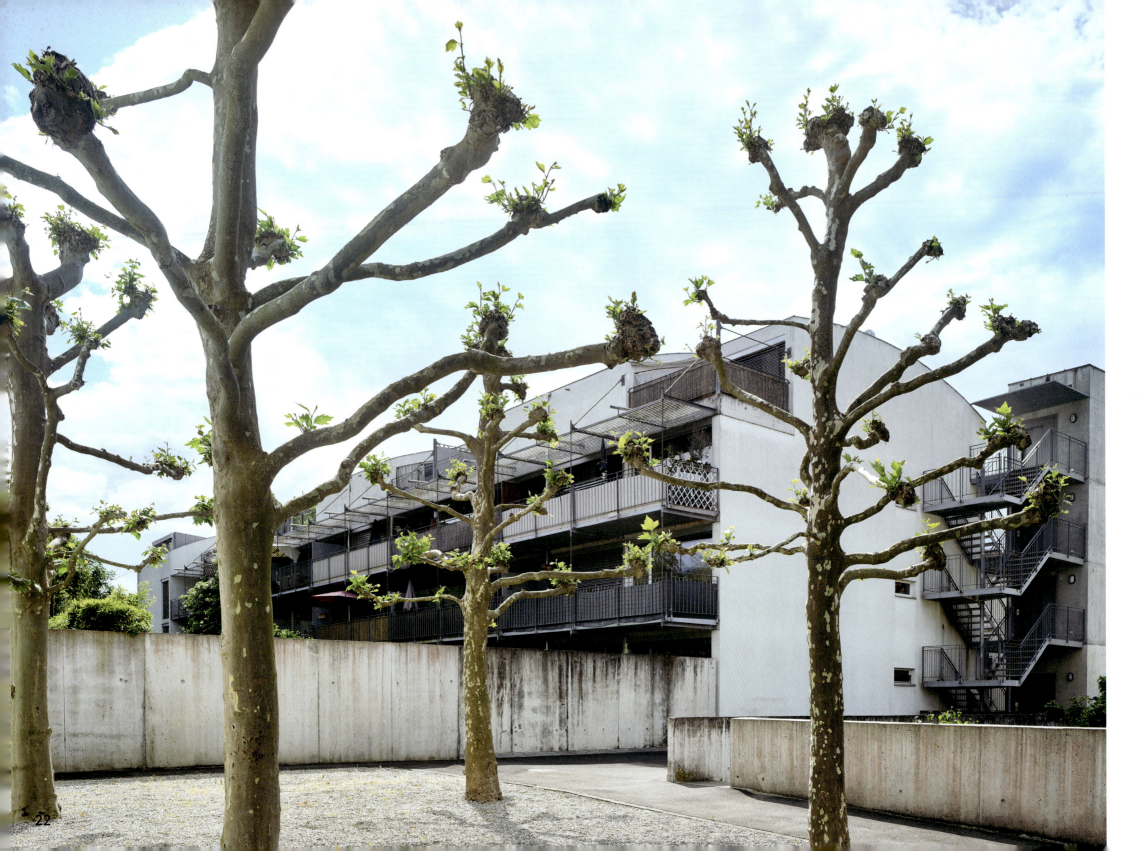

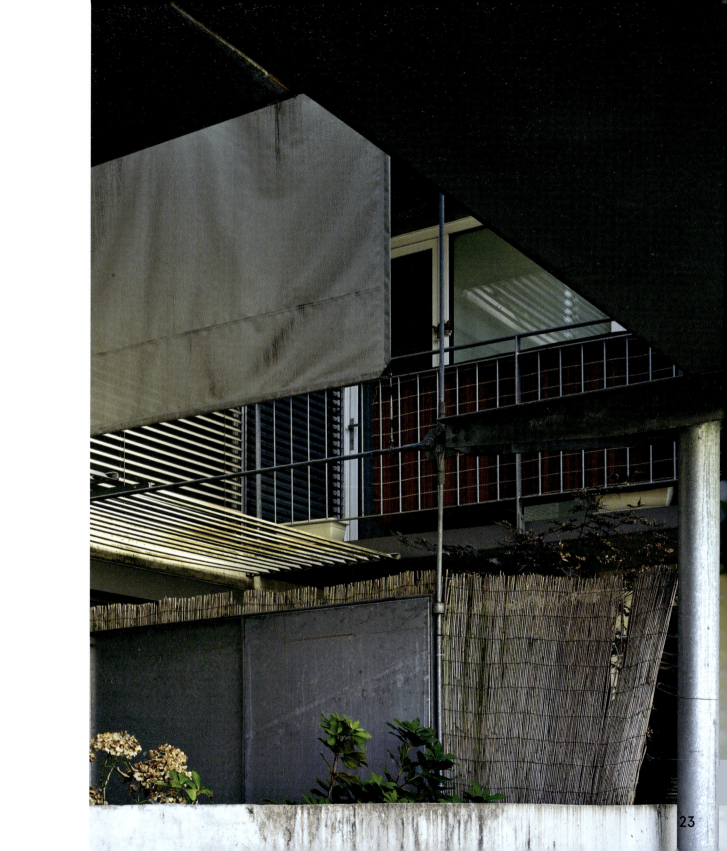

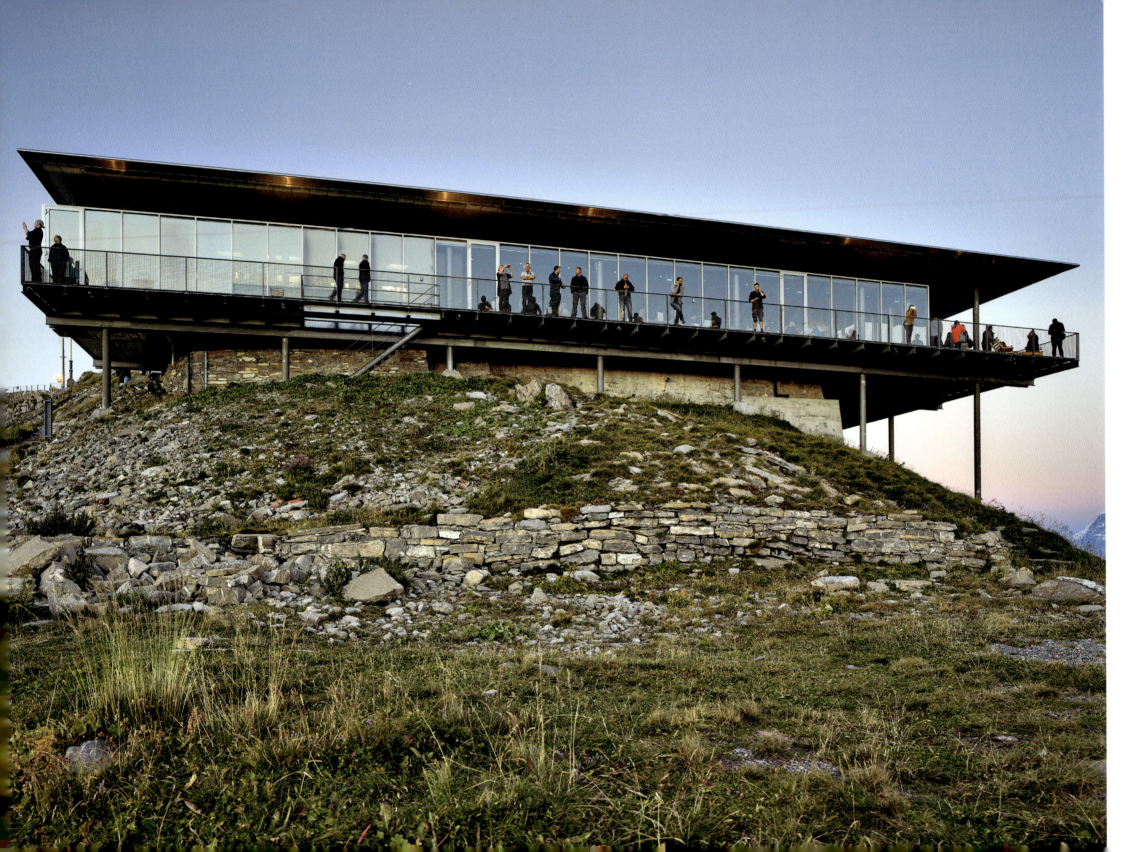

Niesen She avoided going outside and instead watched from inside, watched how the light lay across the mountaintops, how the light was shifting, and she resolved not to miss the moment when the light disappeared from the mountaintops. She wanted to be looking right then, wanted to see it disappearing.

But the moment was so fleeting that she couldn't pin it down. Suddenly the mountains lay in shadow. The sun glinted briefly behind the peaks, then disappeared completely. And with the sun, the tourists, too, disappeared back inside the building. Pushed their way towards the tables beside her.

She listened to the buzz of voices and leaned her head against the window and looked through the glass. Like a ship, she thought. Like being inside a ship with the waves outside, the blue. On the glass she saw grease marks left by fingers, perhaps the fingers of tourists pointing at mountains, or children's fingers tracing the flight of a bird on the pane.

Get away from it all – that was everyone's unsolicited advice. Why not take a trip, they said, it'll work wonders, a change of scenery, clear your head, fresh air.

And so now this mountain, this Niesen, and this crowded panoramic restaurant.

She disengaged her head from the pane and saw her own fine grease mark, the imprint of her cheek on the glass.

She also disengaged herself from the table, left her coffee cup and the paper placemat behind, and went out onto the terrace. People's voices now reached her only faintly. It was cool on the terrace and she was glad to have some peace again. Out here, with just a few other people, who were pointing into the twilight and saying *Ooh* and *Aah* and *Look* and *Beautiful*. Taking photos, mostly selfies, with the dark blue mountain panorama in the background. She purposely positioned herself in a way that meant none of these people could think of asking her to take a photo of them.

She could do that – act in a space in such a way that she was more surroundings than body, more railings than arms and legs, more windowpane than clothing.

A tourist pointed in a southwesterly direction.
It must be over there.
What? her companion asked.
Mont Blanc.
Ah, OK.
Yes. But it's too dark now. And the air wasn't clear enough today anyway. The view hazy.
Ah. Too hazy.
Yes.
What a shame. So we should be able to see it over there.
Yes, technically, over there, said the tourist, and they both stretched out their arms towards the invisible Mont Blanc.

She looked back inside through the window, saw the chewing mouths, the mouths that were laughing, the corners of mouths that were twitching, the shining eyes, the hands that were spearing pieces of bread on forks and stirring them with forks in cheese, that were refilling wine glasses, the hands on top of hands and on shoulders – she saw the joy and the warmth and the pleasure and the enjoyment. And the windowpane became metres thick.
She wished that one of those mouths and one of those hands belonged to her. Instead, she pressed her lips together and felt the icy railing in her hand.

With the last train, almost the last tourists left the panoramic viewing point.
She had read on an information panel that the mountain on which she was standing was lifting upward by 0.4 millimetres per year. That it was eroding, on the other hand, at an annual rate of 1 millimetre. That although the mountain was growing, it was actually shrinking. 0.4 millimetres. She herself had a general feeling of shrinking, of becoming steadily less from year to year. She was afraid she was disappearing herself.
She looked down into the valley and was glad of the 2,336 metres above sea level, of the funicular railway 3,499 metres

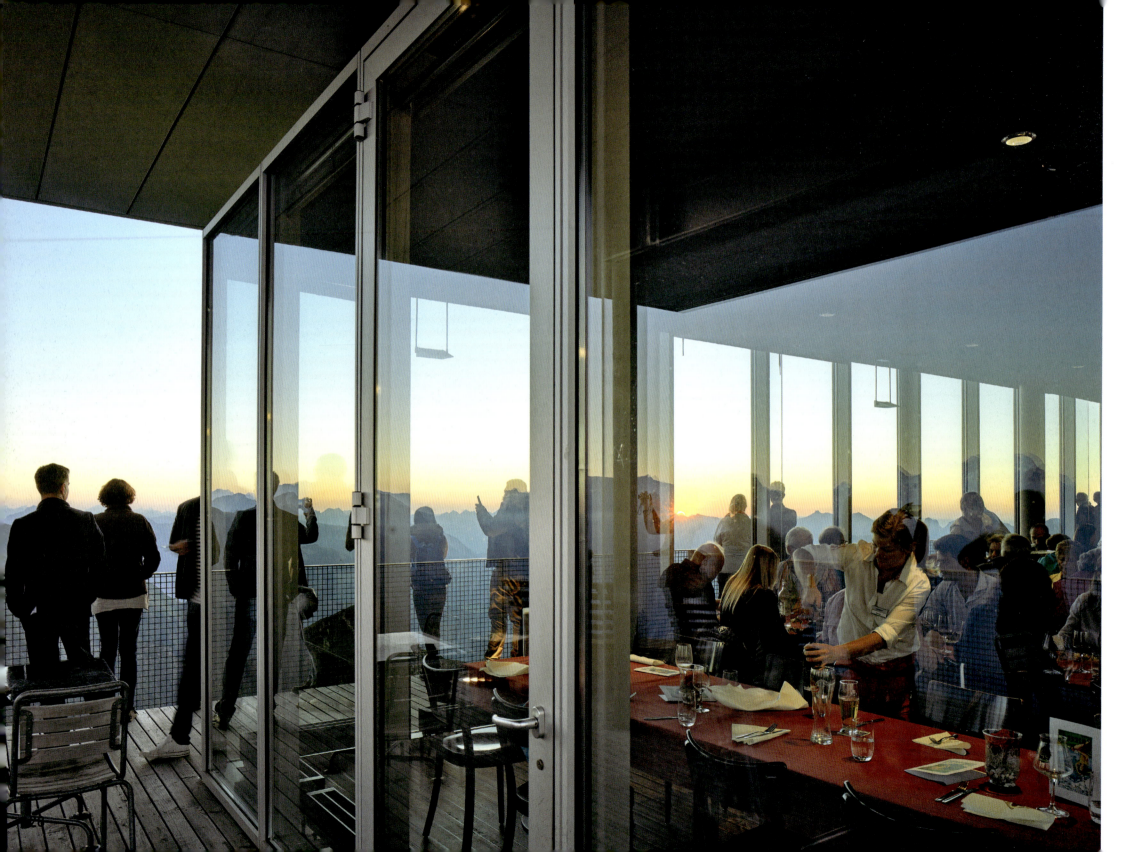

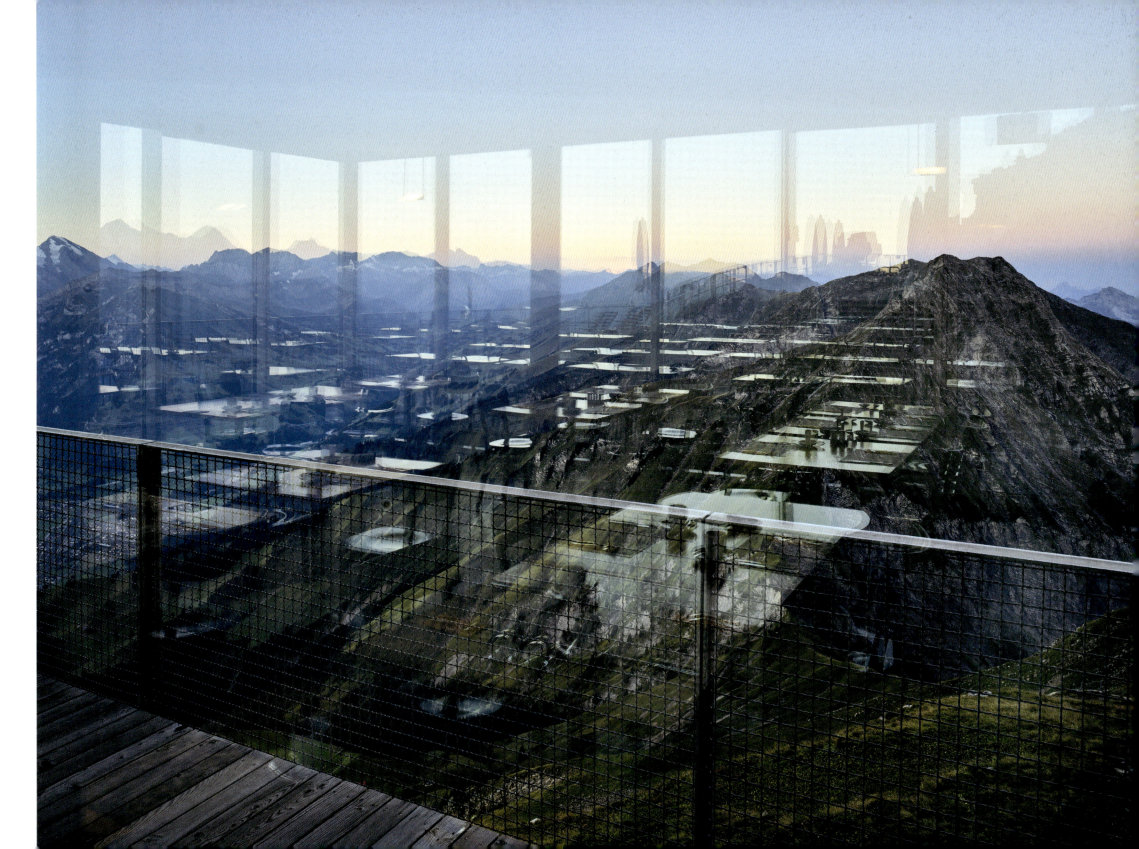

in length, of the 11,674 steps separating the top from the bottom, the bottom from the top.

There are worse views, she thought. And the longer she looked at the dark panorama, the easier she found it to breathe, the better she could imagine her own growth besides her own erosion.

She breathed in the air, which smelled of cold and of mountains, as well as of melted cheese and weekend. Although it wasn't the weekend and the food had long since been eaten and cleared away.

Night fell over the mountain. The last tourists withdrew to their hotel rooms.

Now it was quiet. Quiet and dark.

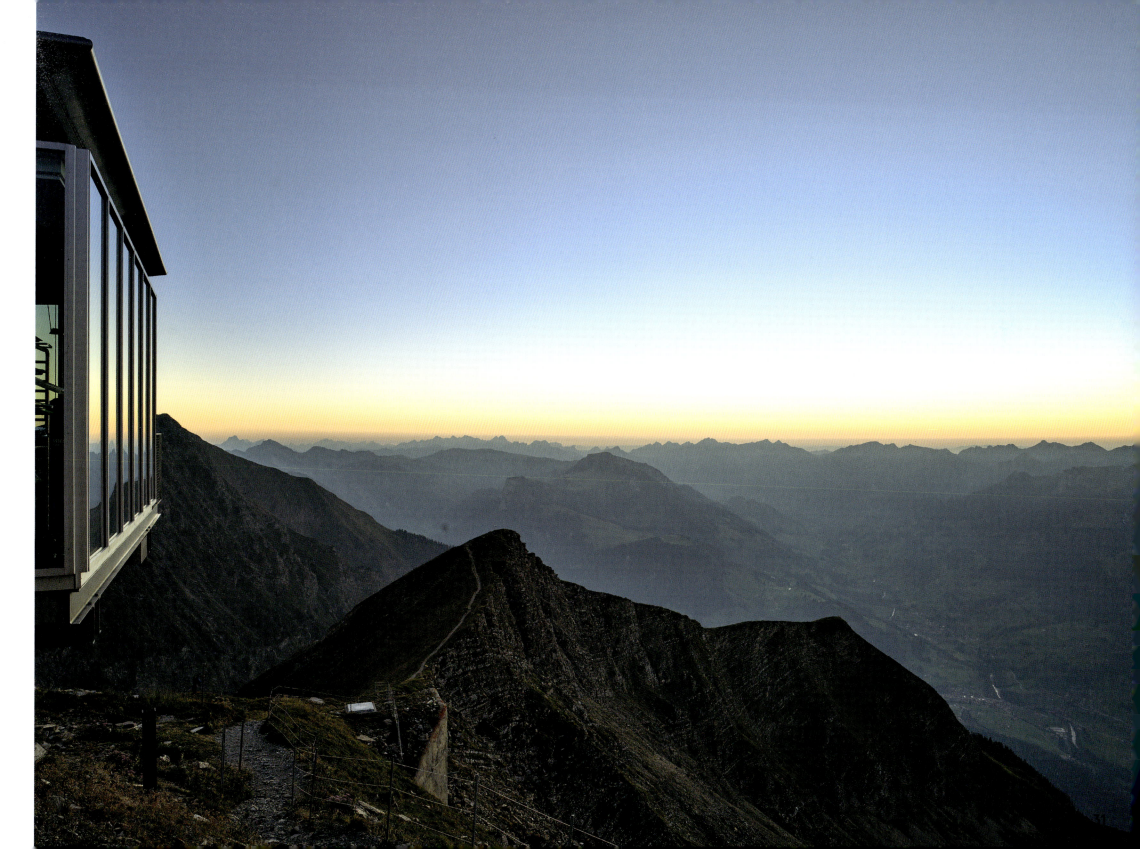

Appearance Maybe an accident, maybe she is being tended to right now by passers-by who saw her lying by the roadside, maybe she is already in hospital with one or two broken bones, a cut, and feeling furious with Kasimir, or Mientus, or Mephisto.
She has got separated from the horse. Been thrown off somewhere. Or else has jumped off, saddle and all. Has bolted.
Is perhaps already just outside Nice, in a comfy train compartment with a landscape passing by sedately outside. Nothing that jolts, no sweat.
Or maybe, thanks to the horse, she has made it to the theatre in time after all. Maybe she is seated at the very end of a row, her heart pounding from the fast gallop. And during the final applause, she is also clapping for Kasimir, or Mientus, or Mephisto.
Or perhaps it's not about her at all, but purely about Kasimir, or Mientus, or Mephisto, who planned his appearance far in advance, who mounted the stage facing towards the city and clearly visible from the city.

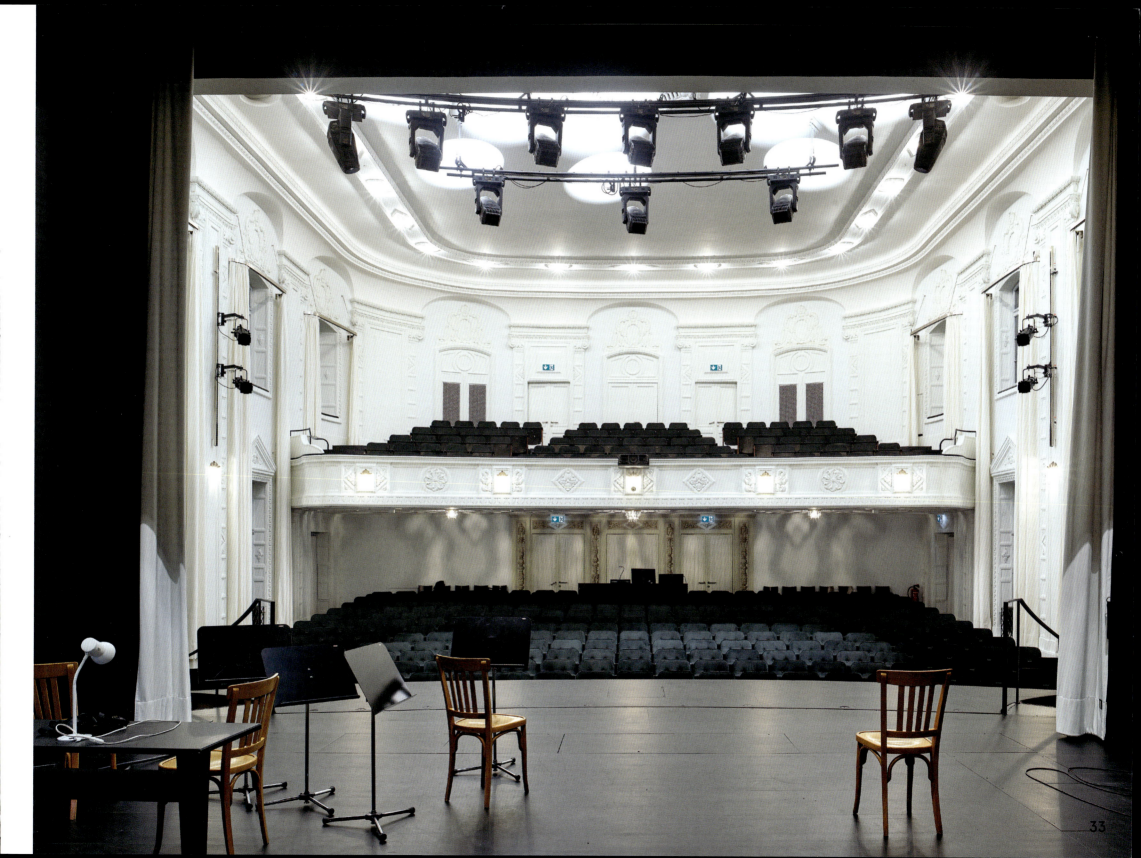

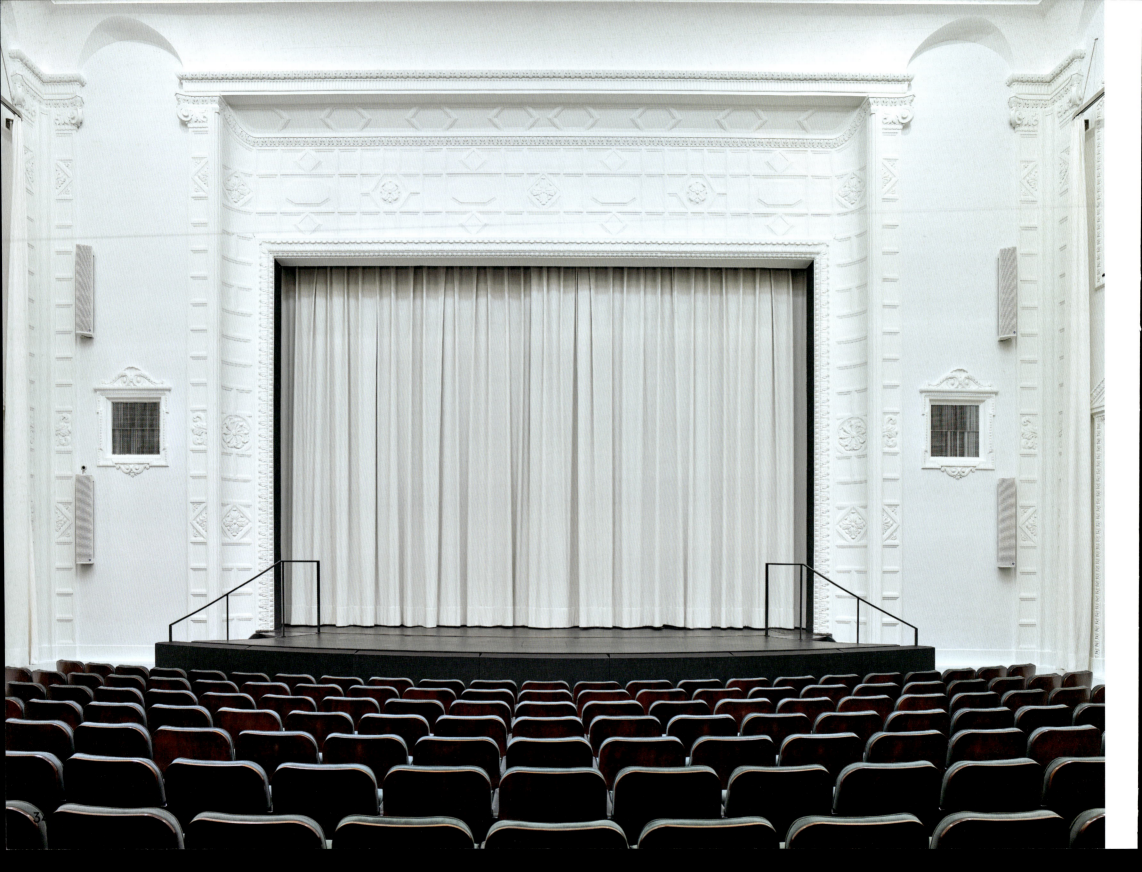

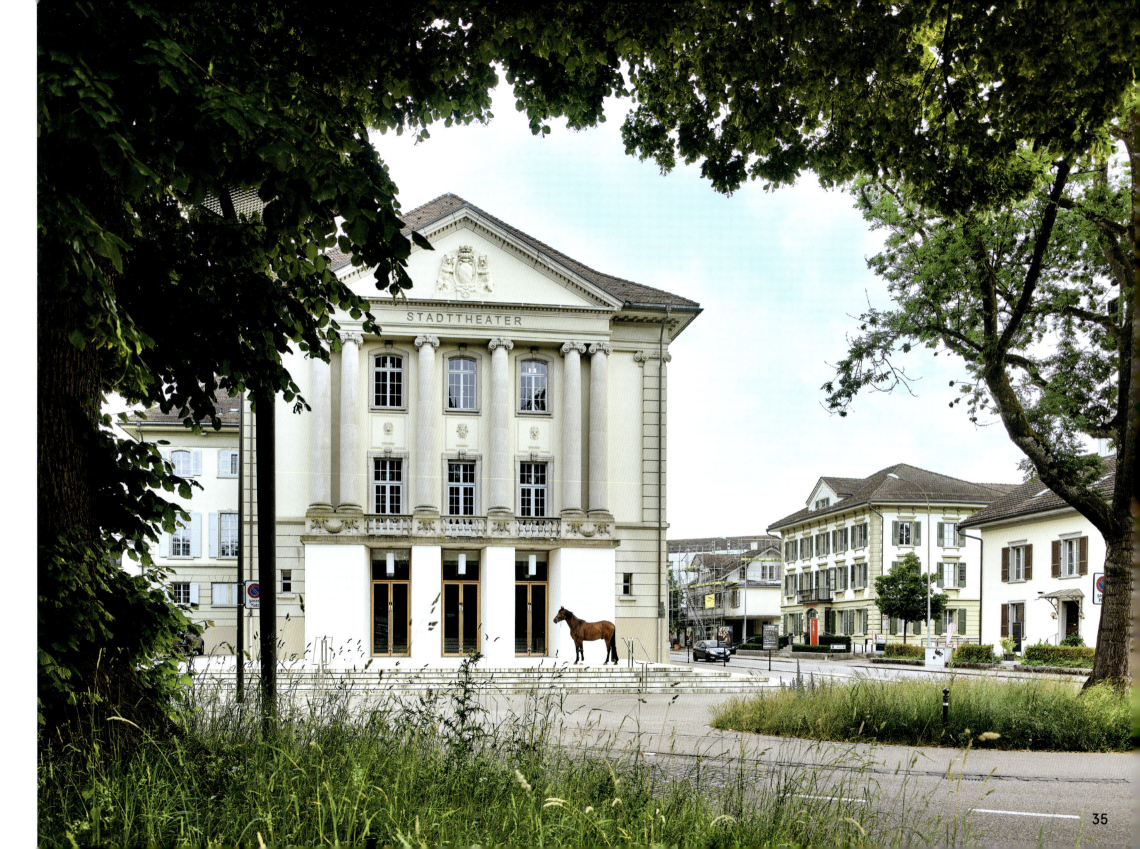

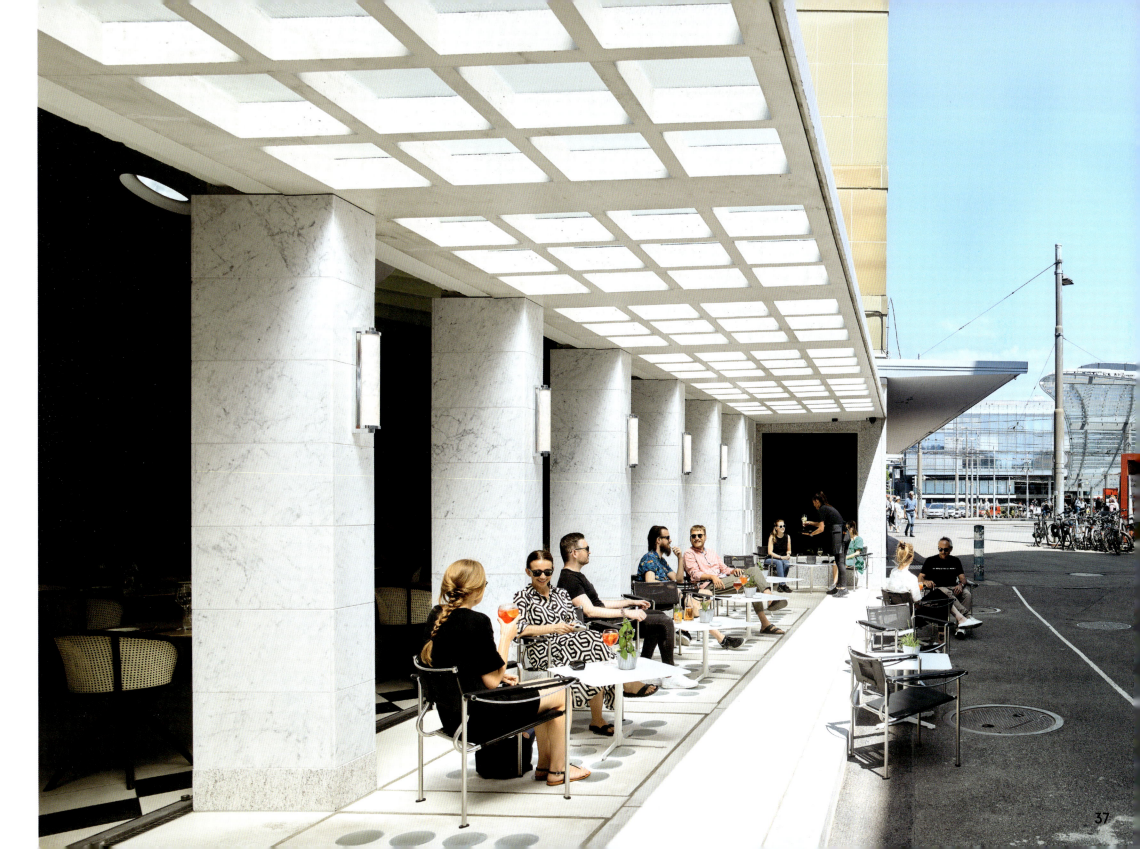

Administrative building The cook in the canteen feels safe in this building.
Pillars present arms to the former armoury. A house built around a *Zeughaus*.
Once you're in, you can't get out again that easily.
But you can't get in that easily either.
It's his second week in the job and he already knows three shortcuts inside the building, where the sunny spots are in the atrium, and the cycle of the large fountain in the courtyard, which indicates the hour of the day with its twelve water basins, which it fills one after the other.
While the cook thinks about the lizard he saw on the edge of the fountain, he pounds schnitzels. He pictures the lizard passing through the two remaining security gates with no problems and without an access badge, and then speeding towards the atrium to bask in a patch of sunlight.
Would a lizard cause a stir in the atrium? Would people try to catch the intruder?
The chef imagines the in-house security officers surrounding the lizard on three sides, slowly approaching the lizard and encircling it. He imagines how one security officer would dart forward to grab the lizard and how he would miss. How the security officers would then walk stooped down through the atrium and the rest of the building for days, looking for the lizard. And he imagines the lizard sitting in a plant pot and watching the goings-on from there, not without interest – quite the opposite, in fact.

Later, the cook takes a break. He takes a seat in a sunny spot in the atrium, looks up at the glass ceiling, sees the gridded sky. Light comes in.
He himself has to pass through three security gates every morning in order to get into the building.
Not everyone can just walk in; an access badge is the bare minimum.

As he dips schnitzel after schnitzel in flour, egg, and then

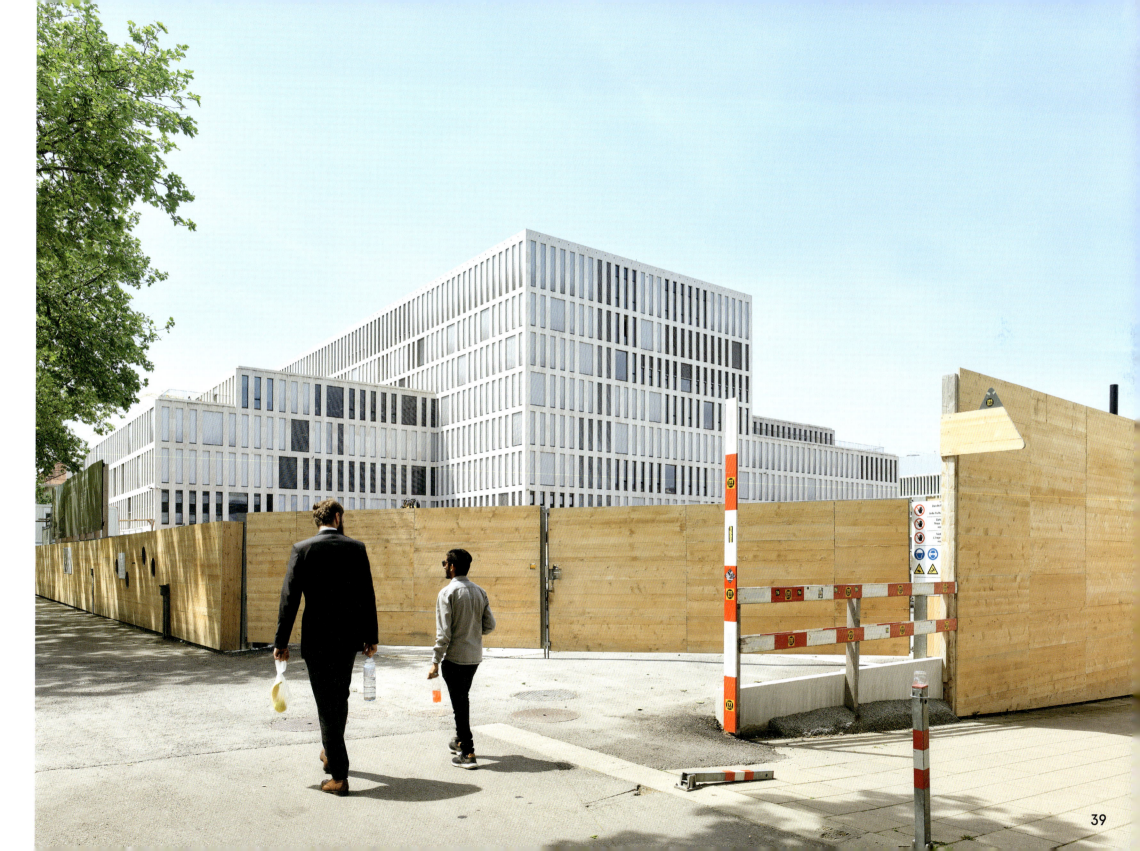

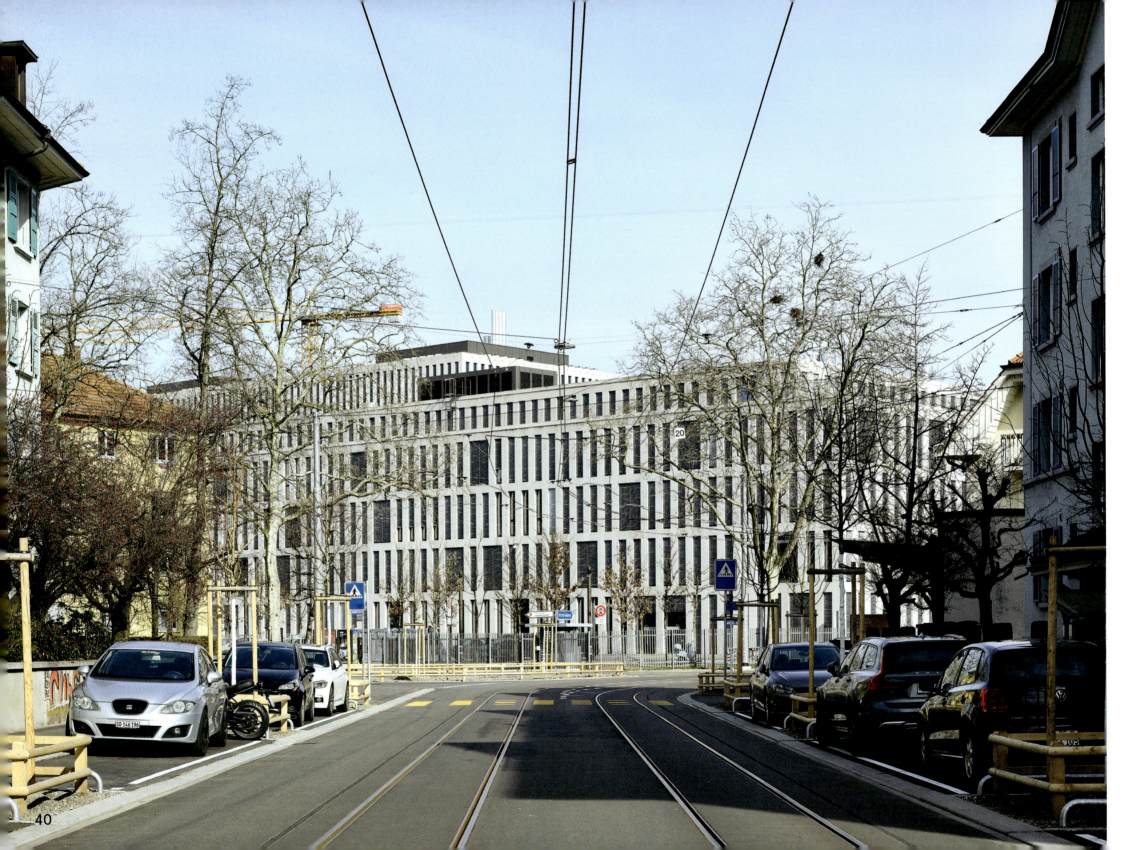

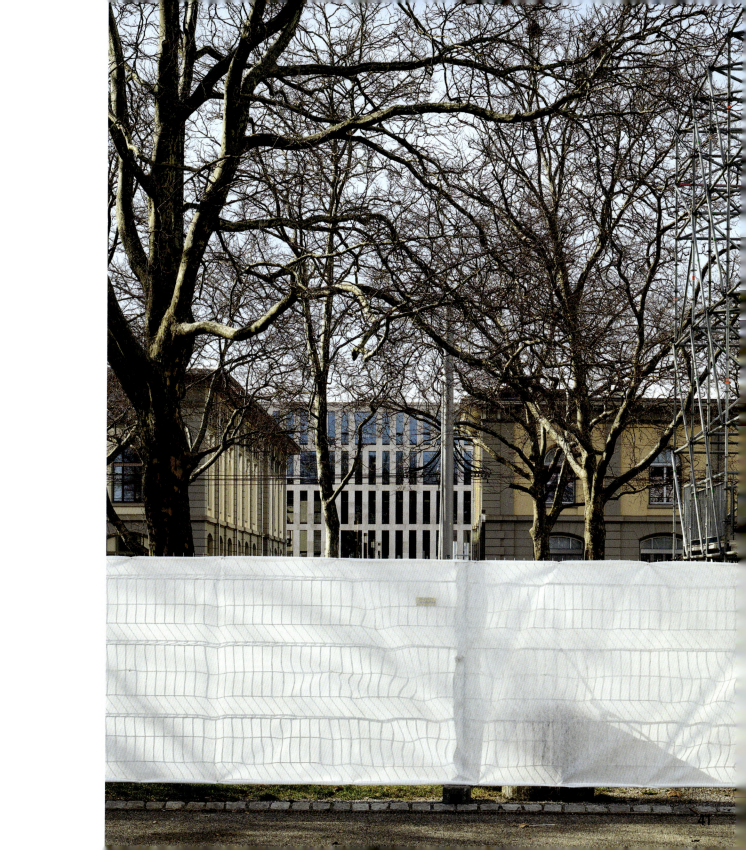

breadcrumbs, the boss comes by and looks over his shoulder. Overall, the chef has the feeling that someone is constantly looking over his shoulder. The surveillance cameras on the façades, inside and on every corner, belong to this building just as slices of lemon belong to a schnitzel.
This is a safe workplace, his boss said at the job interview; people will be keeping an eye on him.

The cook imagines the lizard's slender legs and the scraping sound of its small claws on the terrazzo flooring. Its shadow-like body slipping away just in time behind and in front of government-official feet. Climbing up the atrium wall, taking refuge in a break-time alcove furnished specifically for breaks, with colourful furniture of good design. There it squeezes itself into a fold of fabric and rests.
He imagines the lizard's pounding heart.

When the cook, along with the government officials, leaves the building, makes his way outside, passes through the second security gate and stands in front of the fountain, he looks for the lizard. It is lying not far from where he spotted it that morning. The cook nods at it. The lizard doesn't move. Only when the third gate closes behind him does it slowly raise its head and look in his direction.

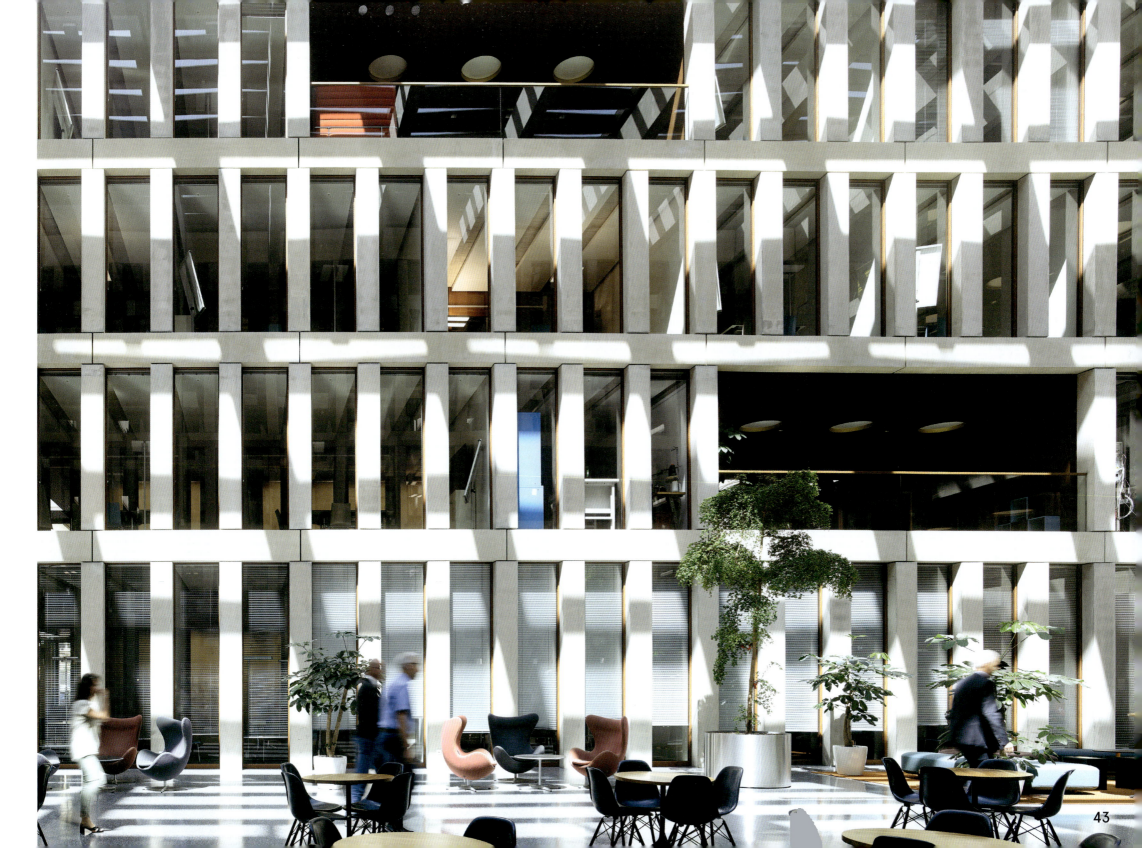

Youth hostel Now they're all in bed inside and asleep, or whispering through the darkness, or tiptoeing from room to room.
And awake they are at the river and dance.
And at the bottom, pebbles clink.

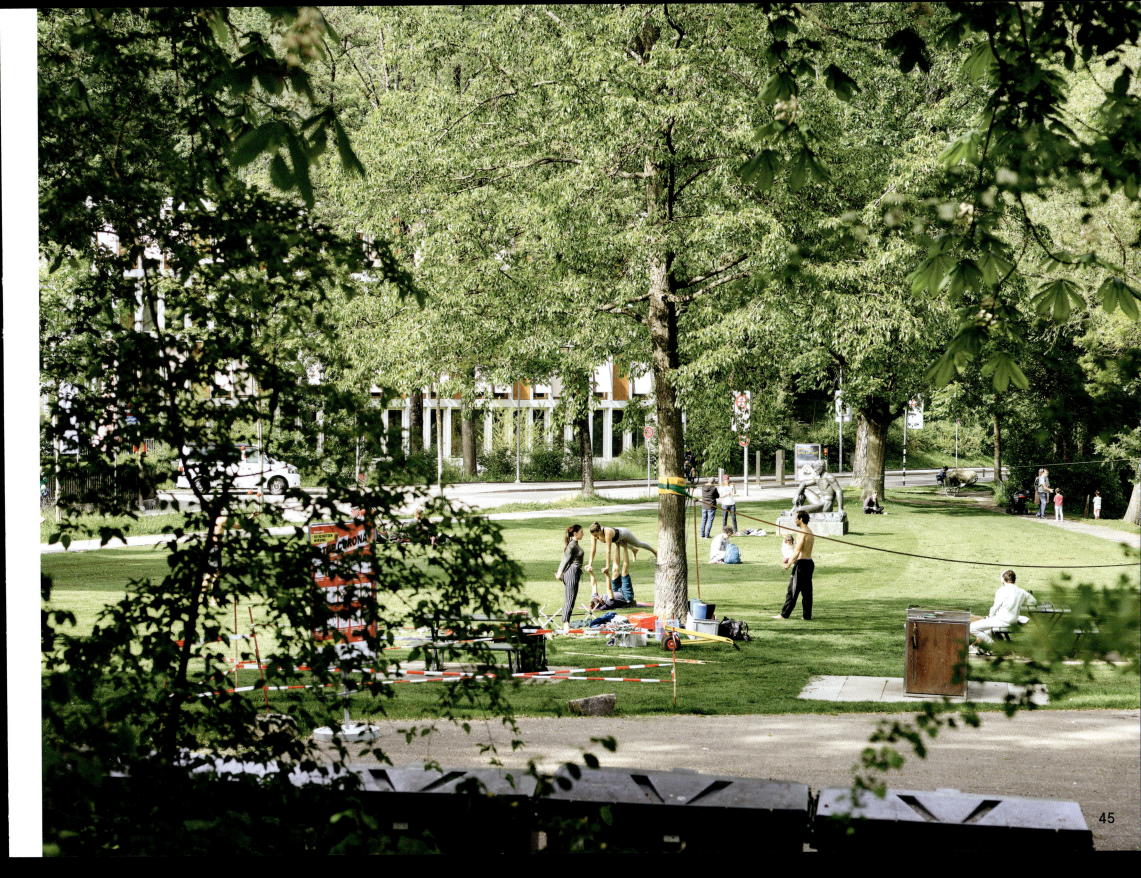

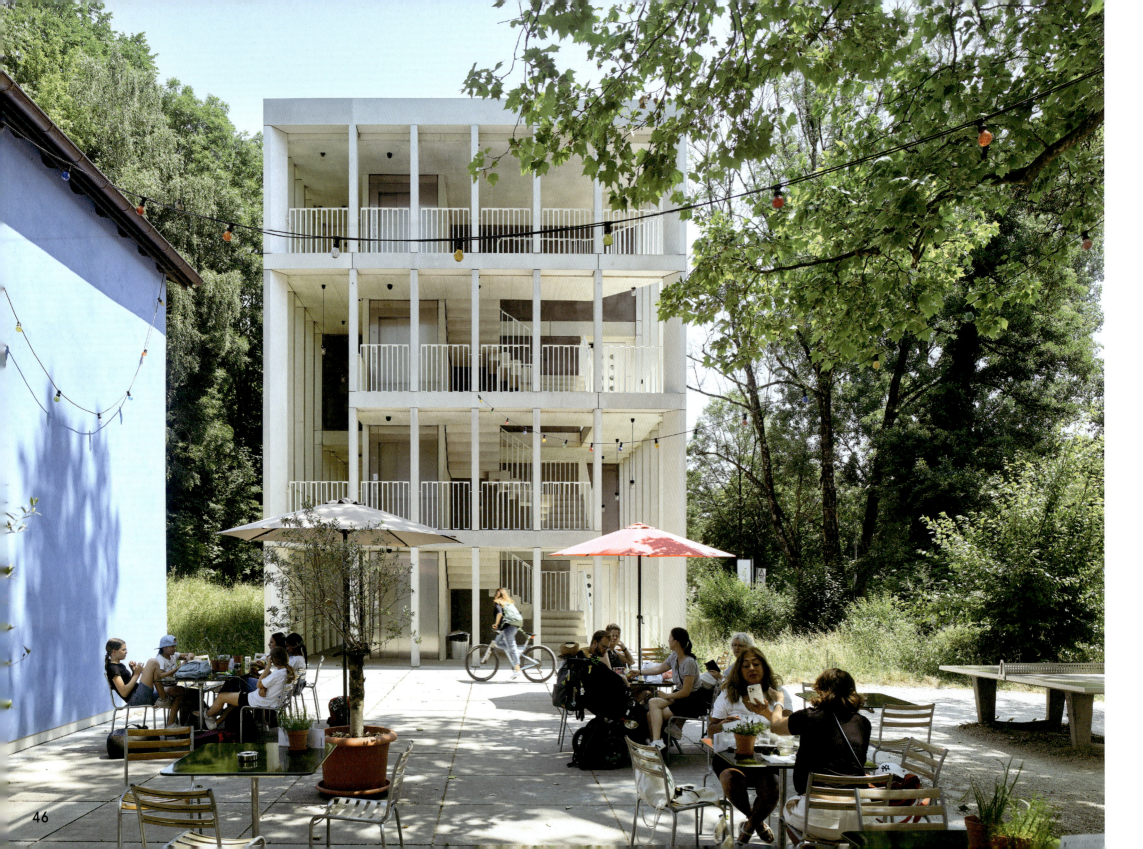

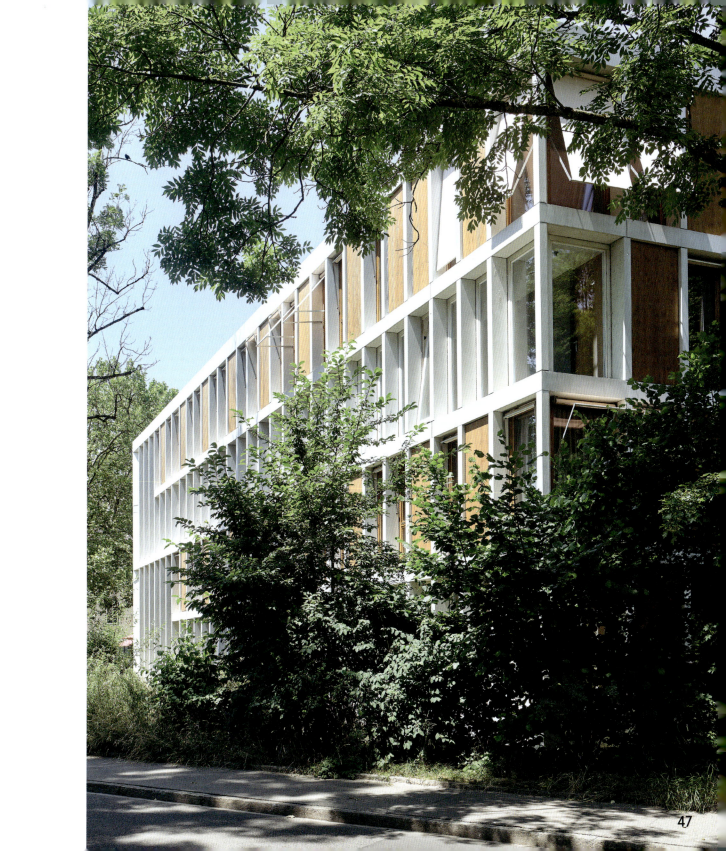

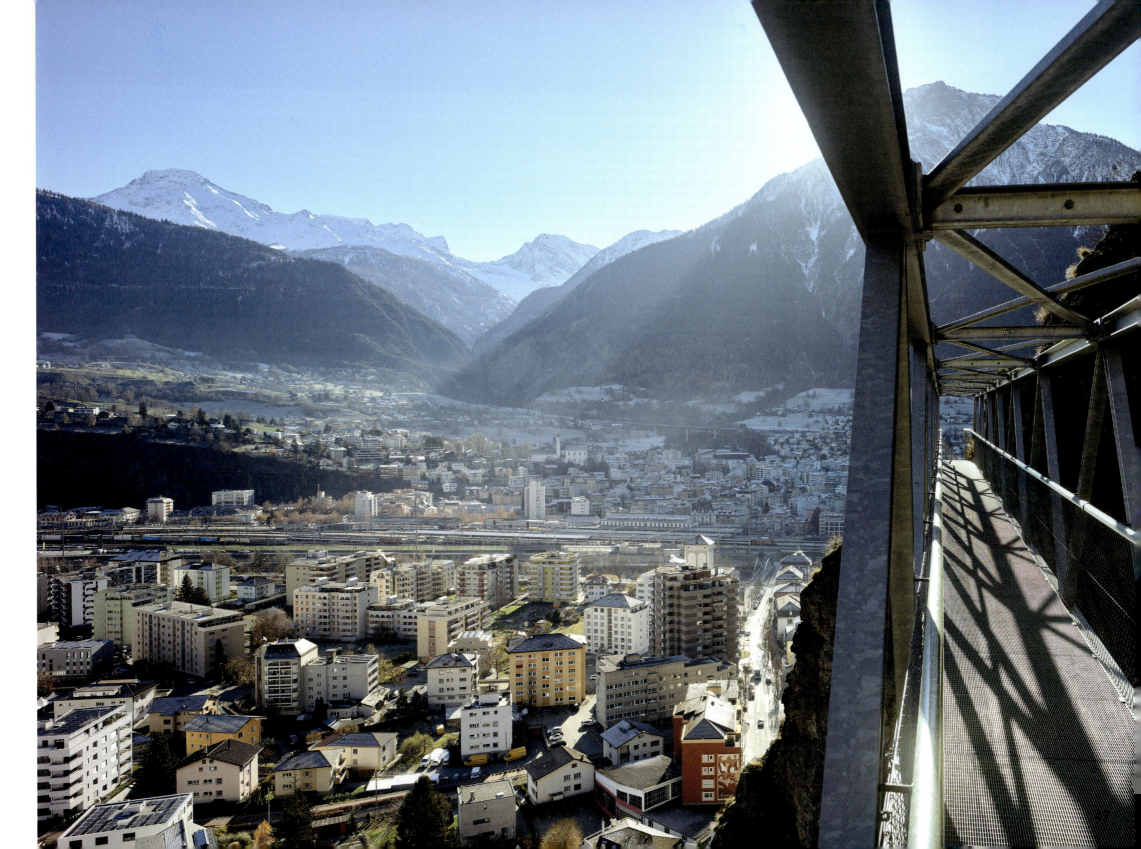

In the future The village's oldest resident is a linden tree. She is over 600 years old and hence was already standing in her present place when construction commenced on the Simplon Tunnel, when the steam engine was invented, and even during the Thirty Years' War. She has survived earthquakes and floods. And generations of other villagers – she has outlived them, too.
The linden may be old and hollow, but she is still keenly interested in the local gossip. And so she dispatches the bird who roosted on her overnight to go and get the village news. The bird, who has only just woken up, grumbles at first, pecking at the linden's bark. In the end, however, he takes flight, spreading his wings and flapping over the village, which nestles against the Rhône in the shape of a fish.

The village lies on alluvial deposits, the bird knows that. The linden has told of how the river flowing out of the glacier carried down stones, gravel and debris year after year for centuries. It is a Tunnel village. Material excavated from the mountain lies in great lumps in the riverbed. Among the inhabitants are the descendants of the miners and engineers and their families who built the Tunnel, most of whom came from Italy and stayed. They turned the village into a larger village. And it continued to grow over the years, while the linden lost her leaves and sprouted new shoots, year in, year out. A building would pop up here or there, in a somewhat haphazard, unstructured way. Many standalone buildings shot up with no feeling for the other houses around them, their surroundings or setting.

The bird circles overhead and spots a construction site with a group of people gathered around a house. He scents news. So down he goes. Landing on the edge of a hollow.
Many are wearing work trousers, others are wearing ties, most are wearing helmets.
And one steps up to the microphone:
Ladies and gentlemen, you are about to witness a historic

relocation. Just as rocks were once transported out of the Simplon Tunnel into the daylight, today, too, stones are being set in motion. In a few minutes, the house at number 11 Bahnhofstrasse will travel along the tracks you can see here at a speed of four metres per hour.

The microphone whistles. The man clears his throat and then continues:

In the future, a new entity will take shape here; a fabric will emerge that will halt the locality's decline. For this we need small shifts that bring about great things. So: full steam ahead!

The bird is startled as a rumbling sound is heard, the hydraulic presses go into action and, with a grinding sound, the building weighing over a thousand tons starts shifting from its place, travelling millimetre by millimetre closer to its future location. The bird watches spellbound, only once hastily nabbing a few fallen breadcrumbs as a snack, and stays right to the end, until the house has reached its new site. The grinding stops and the people with and without helmets clap.

Excited, the bird flies to the linden tree and relates what he has seen. The tree shakes her branches in disbelief. Is he sure? she asks him.

He is absolutely sure and wonders whether maybe, if even 11 Bahnhofstrasse can do it, she, too, shouldn't think about a change of location?

The linden mulls it over and then voices her doubts. She speaks of uprooting and high travel costs and says that she wouldn't fundamentally rule out the possibility of venturing the step at some point in the future. But it's still too soon for that, she says – she's in no hurry.

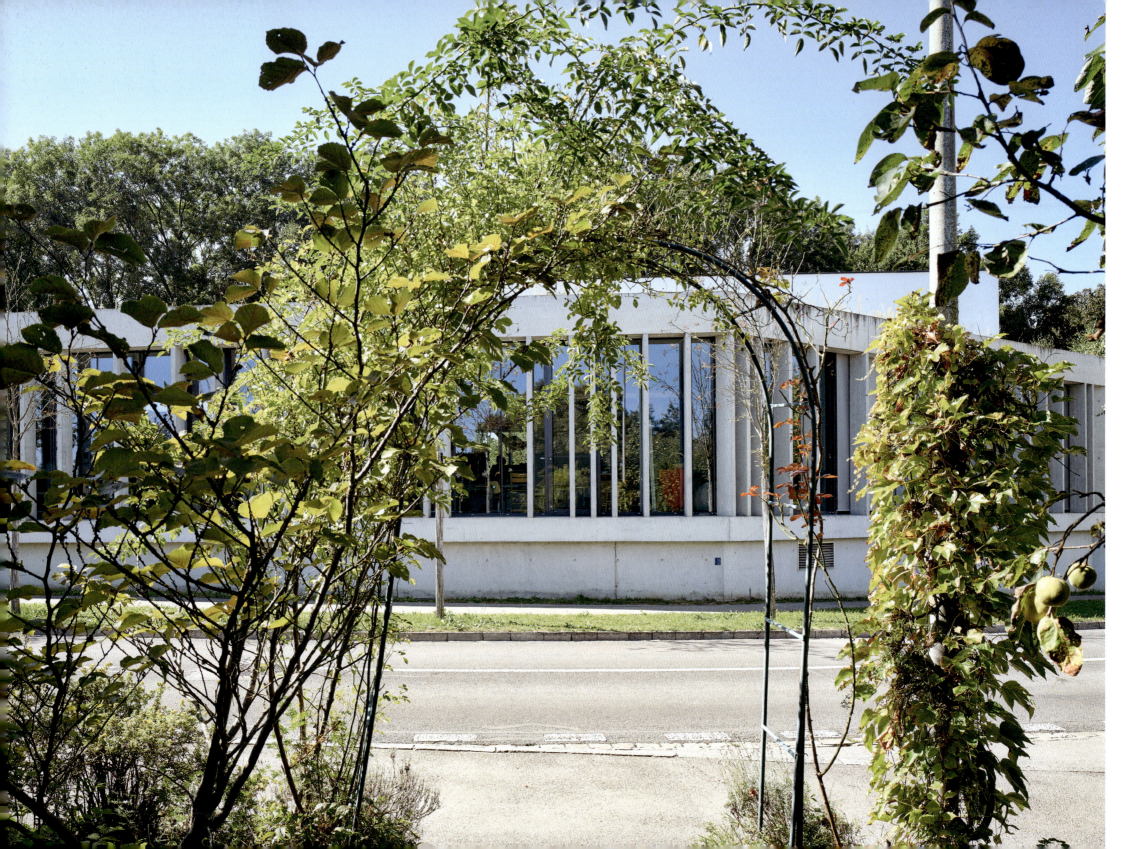

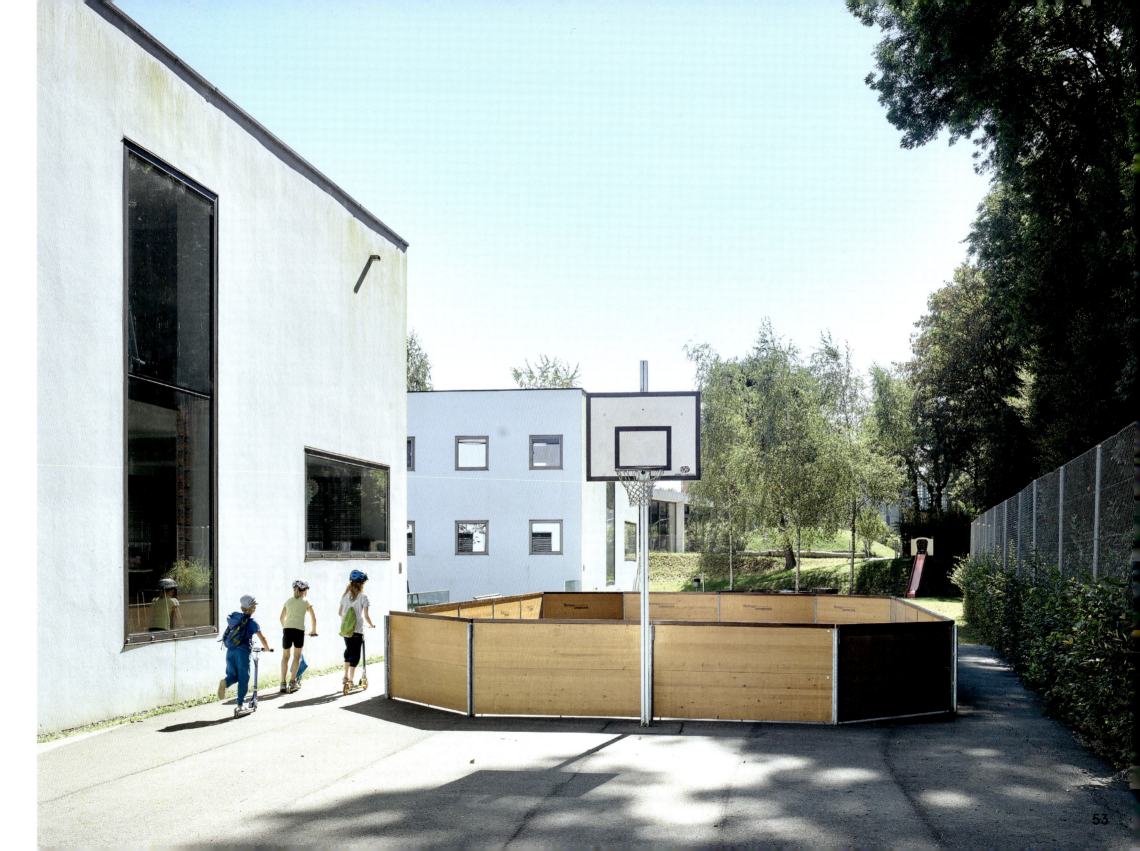

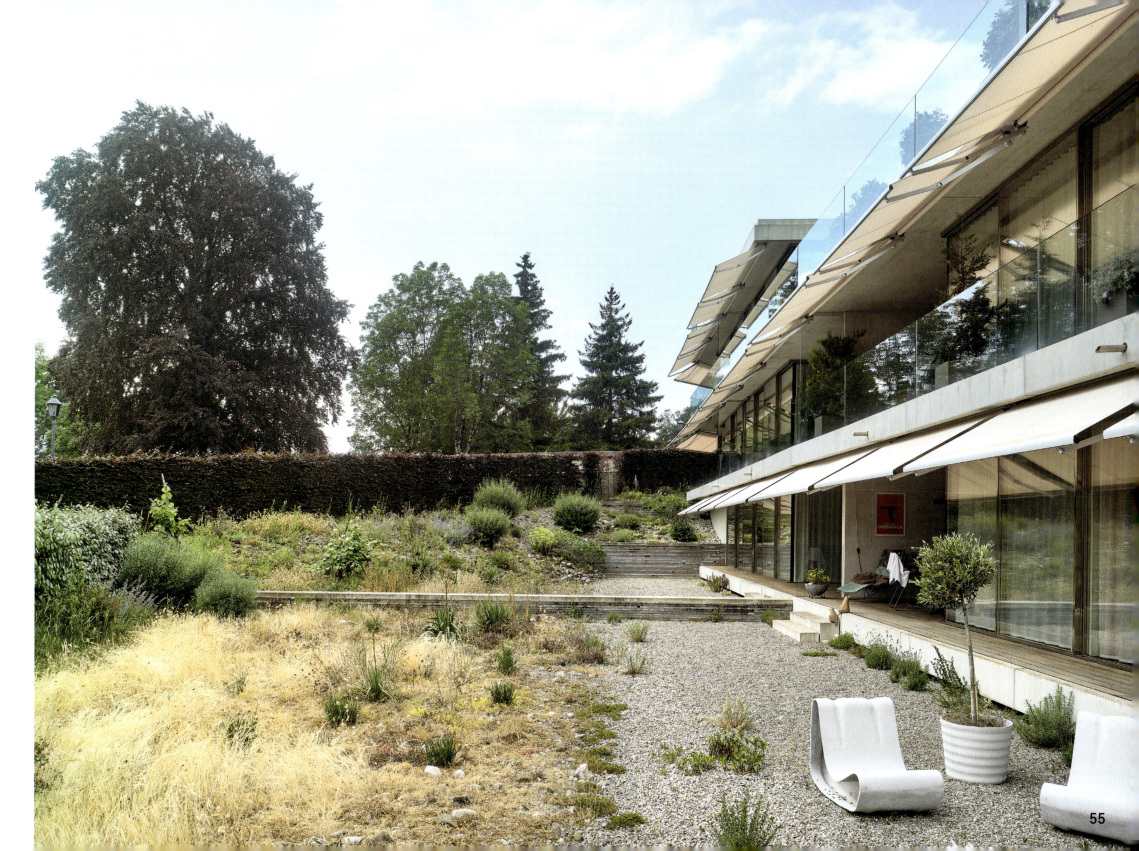

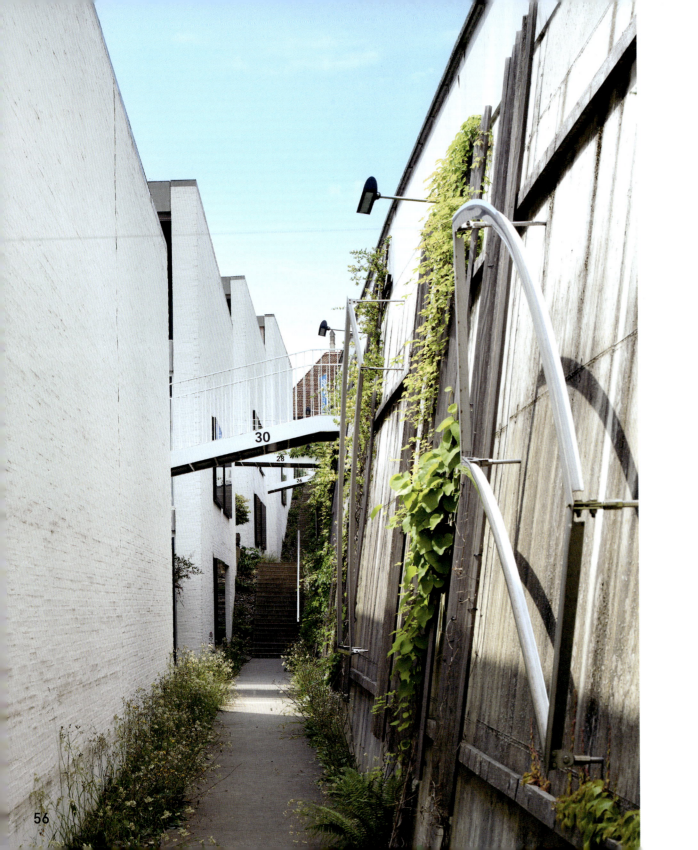

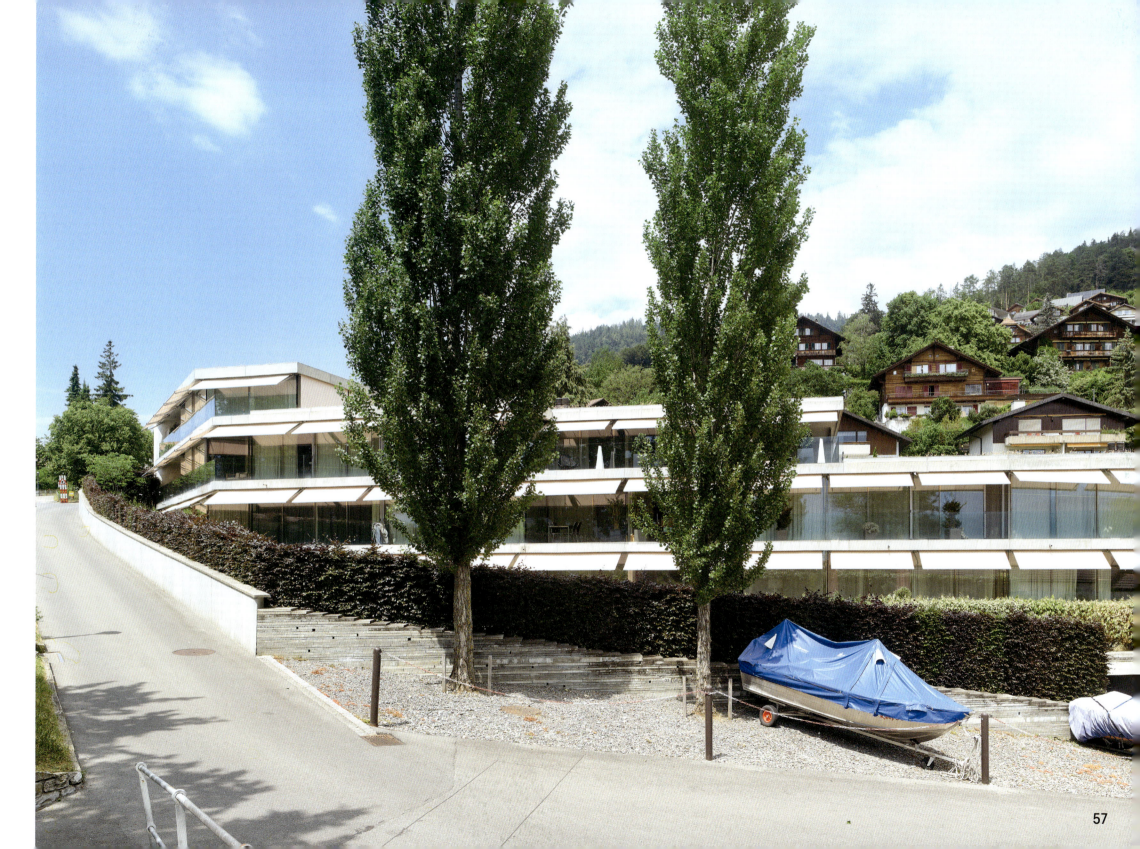

Lido A wall obscures a large part of his view. A narrow strip remains. If he looks out at the right time, he sees a rowing boat or a ferry making its crossing. He can see almost nothing of the lido. Only the diving platform projects above the wall. People are diving from the diving platform. He can't see where they are diving. He can see only that they are diving. And the divers, were they to look, would likewise see him, with sweatband and sweat, sitting on his bicycle behind his large window, and behind him interior furnishings of the finest quality.

Only very rarely does a work colleague catch a glimpse on the screen during an online meeting of the back of a designer chair or a section of mahogany table top.

The wheels of the bicycle whirr. And there is sweat in his sweatband and sweat on his T-shirt and on the palms of his hands and the handlebars of his bicycle, which has never yet been outside. Which only ever rides virtual routes. Today up an asphalt mountain road, S-bends, steep gradient, up to the crest, up to the panoramic restaurant. Up there, he pauses for a moment. The whirr ceases. He looks. And he thinks he can hear the bodies hitting the surface of the water, thinks he can hear their laughter, the jokes, thinks he can smell the sun cream and the ice cream and sun on skin. He releases the brakes and a diver does a backward dive.

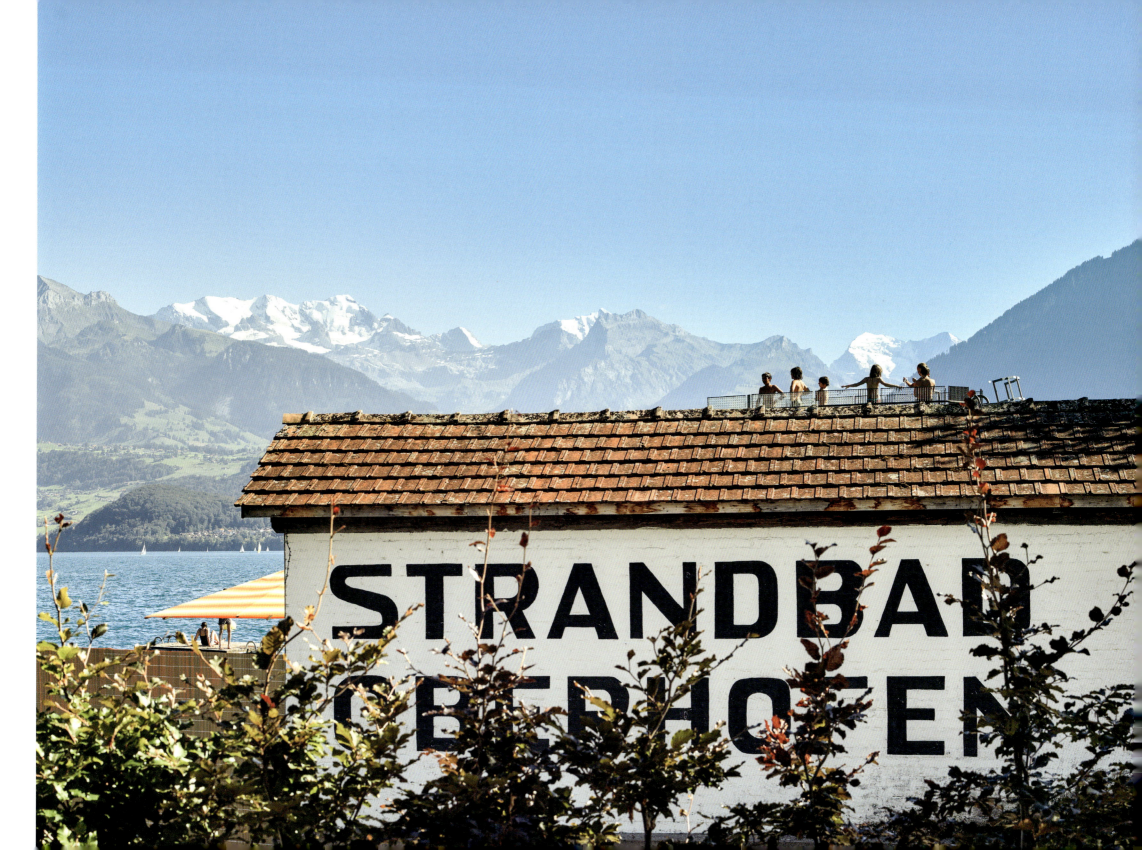

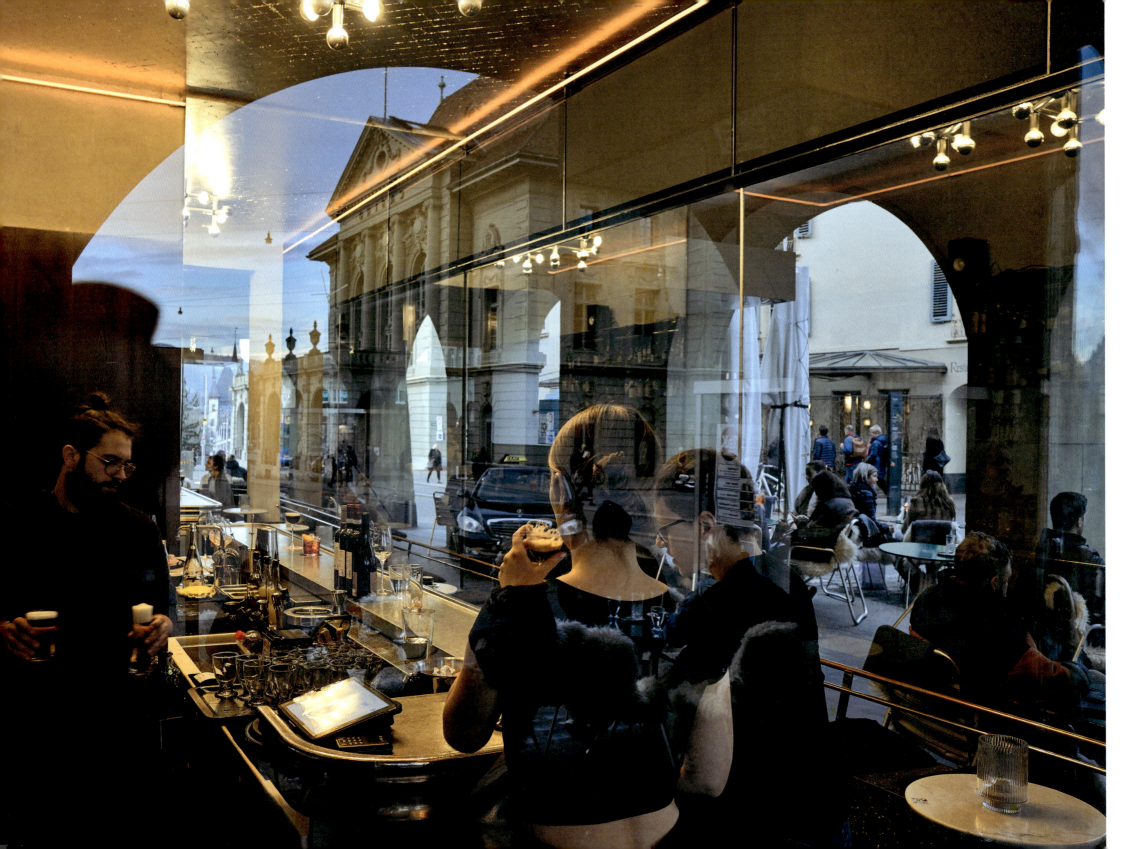

Asino And who knows how many sheets of white gold leaf.
And seashells in the terrazzo.
Even the arcades come into the bar. Entering via the curvature of the glazing.
And only when the lights are extinguished do they spring back outside in a high arc. And the sheets of white gold leaf, the seashells in the floor, and the bar made of pewter remain behind.

Seen from here She has known it all for years. She knows the bench empty, the bench full, the bench with owner and dog, with kissing couples, with young people perched on the backrest, with grandparents sandwiching sausages between bread and handing them to their grandchildren, with joggers stretching their calves, with people waiting, with people freezing, with people sleeping. She knows the lake with waves, with ducks, with courting swans, with bathers. She knows the fir tree, too, with woodpecker, without woodpecker, in all seasons and in all weather, with and without squirrels. She even knows the knotholes.

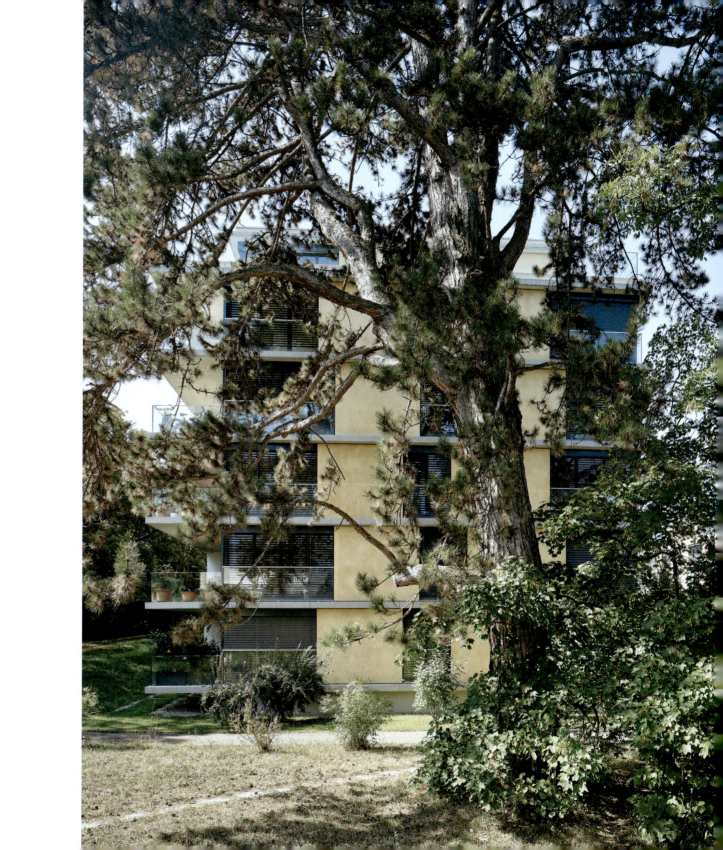

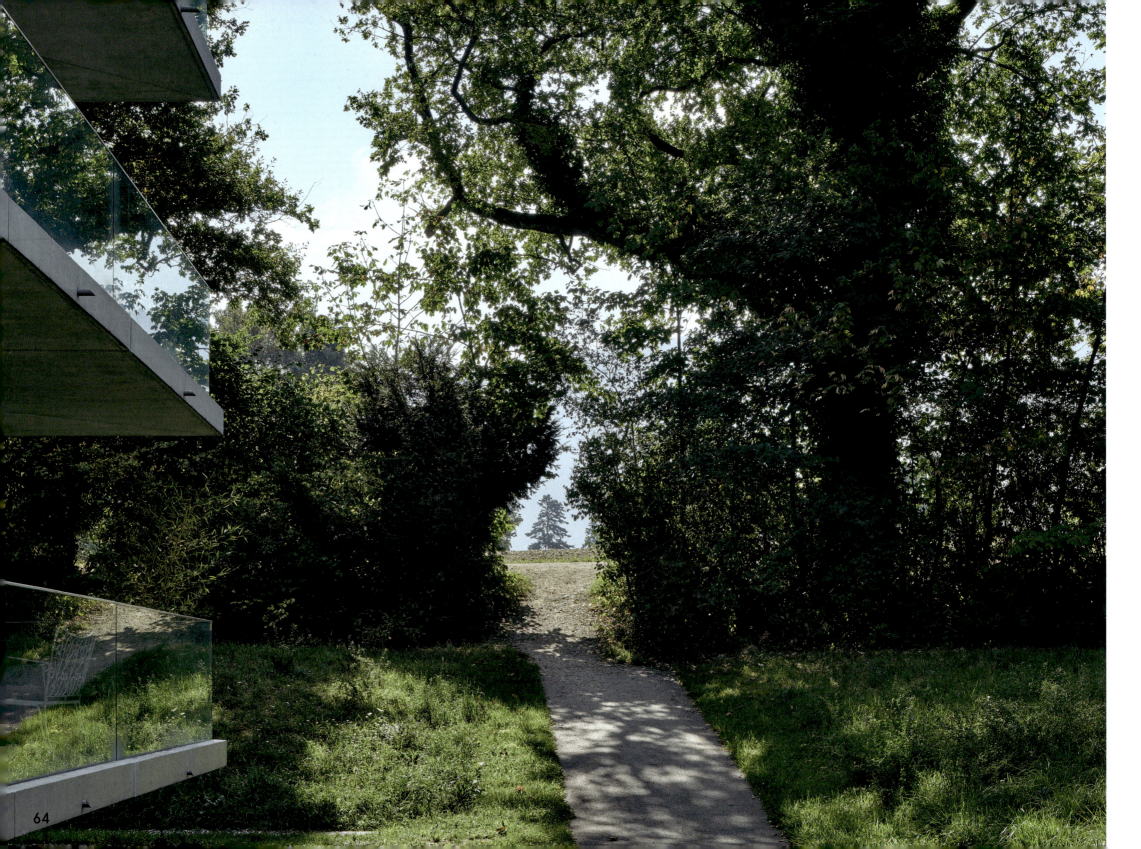

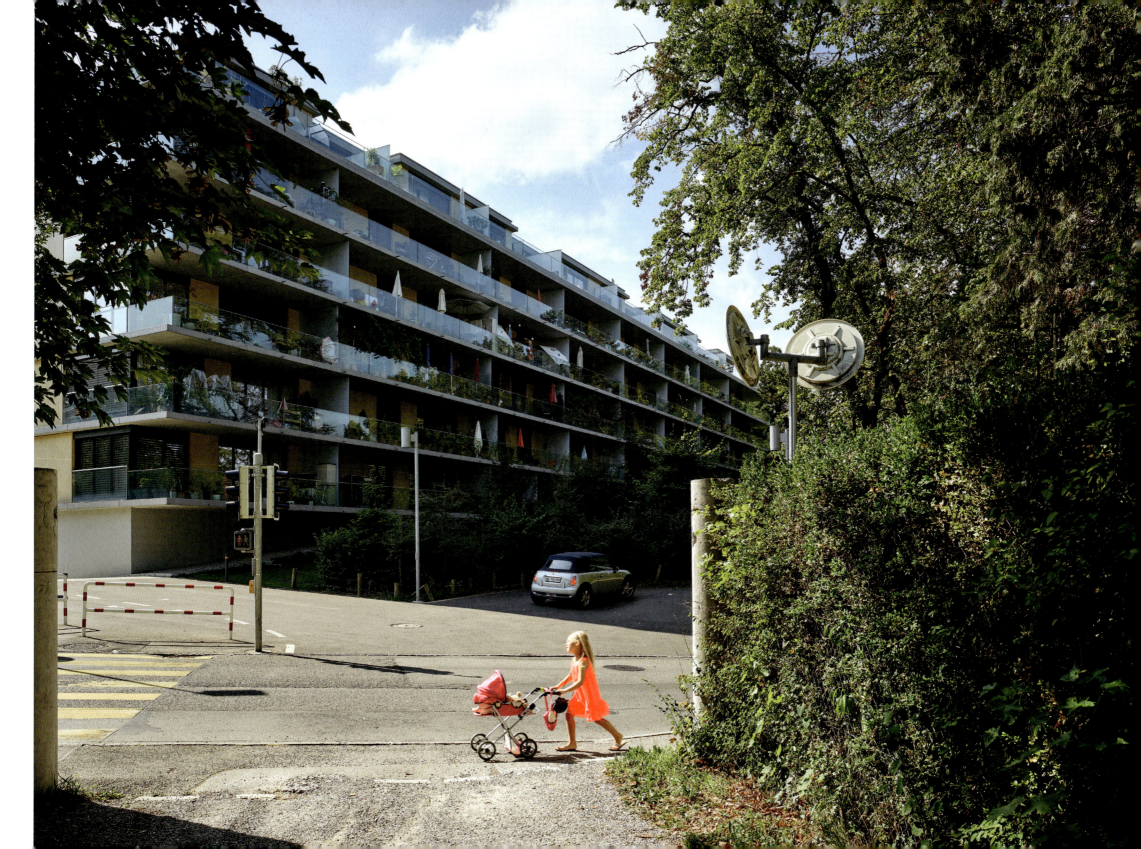

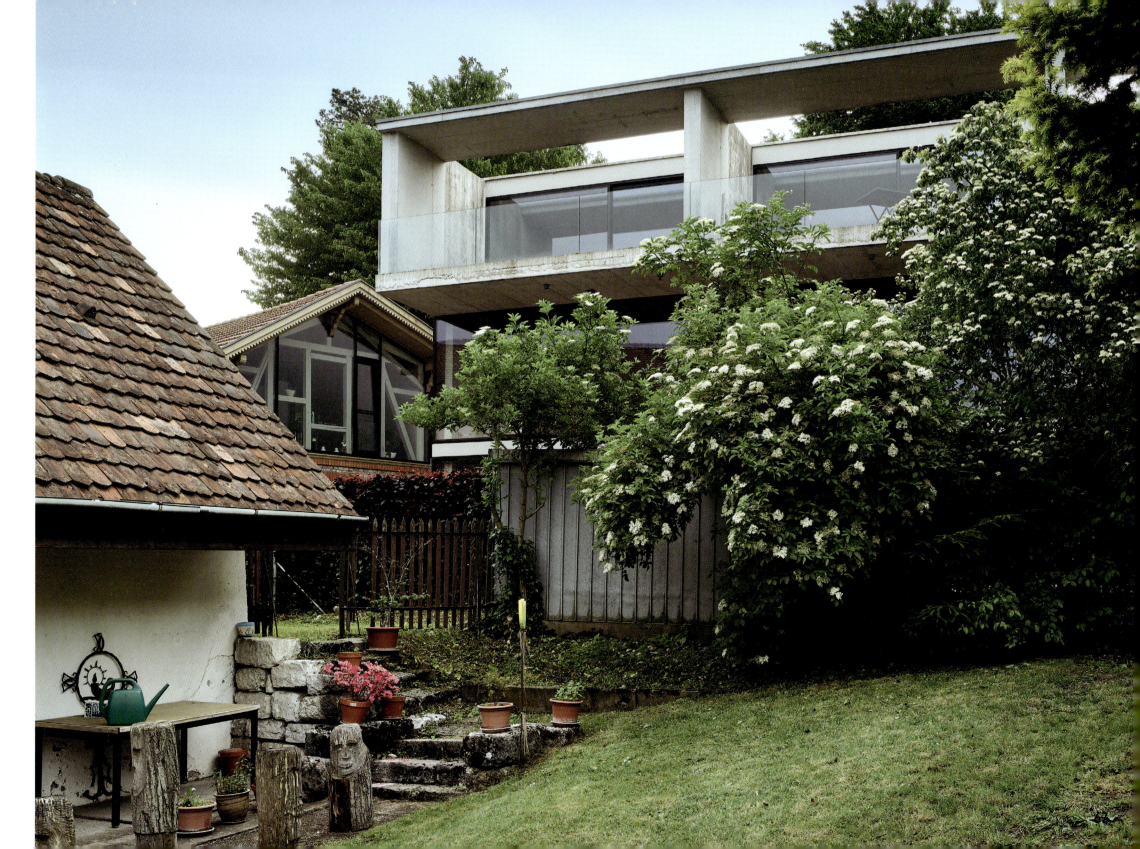

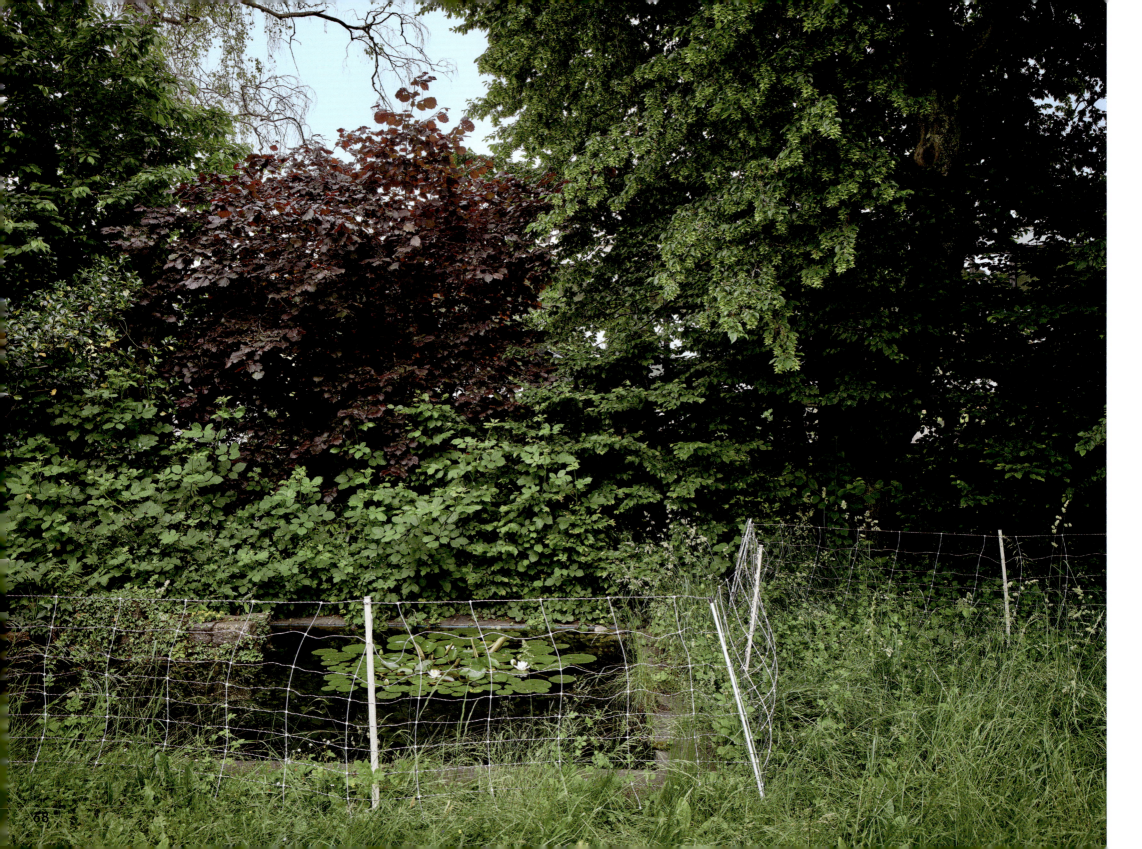

Ground floor The ants have made themselves at home, have found a place to nurture their brood and care for their queen.
What the ants fear:
The foot of a jogger
The hoof of a deer
The claw of a fox
The thumb of a child
Water
Fire
Chalk
Poison.

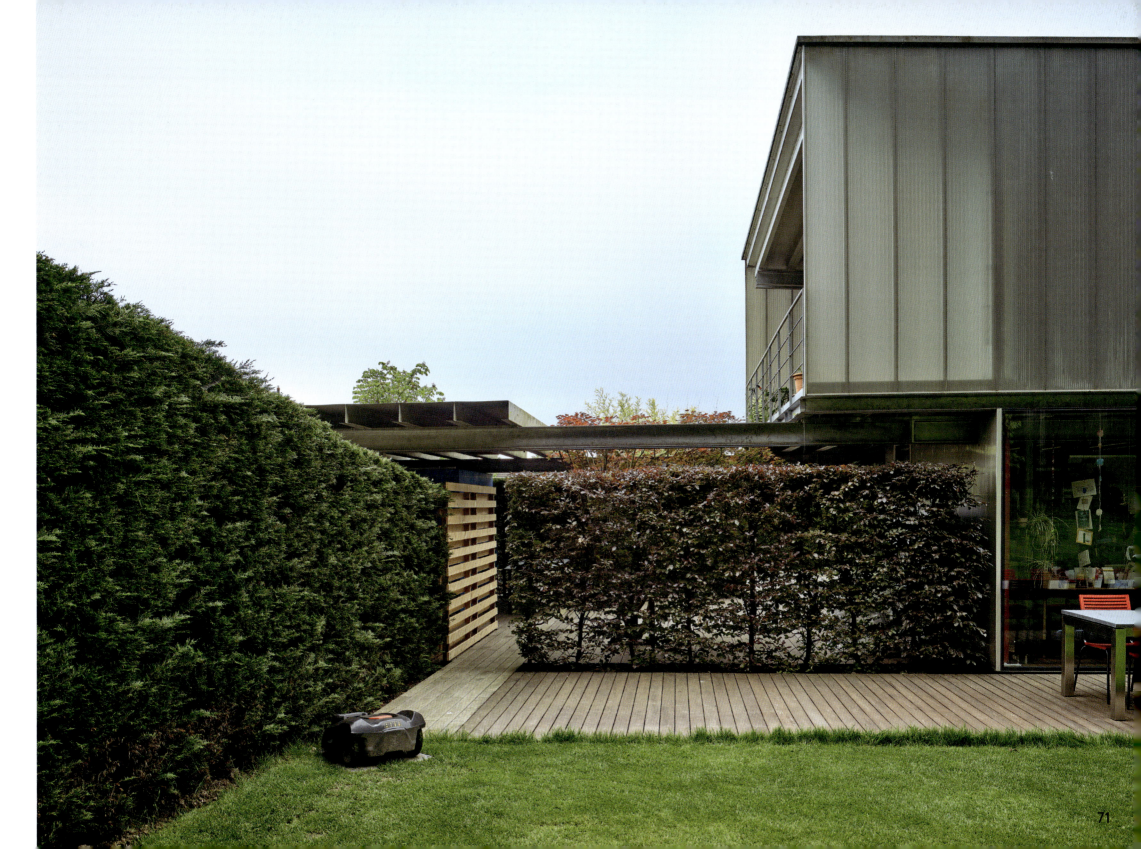

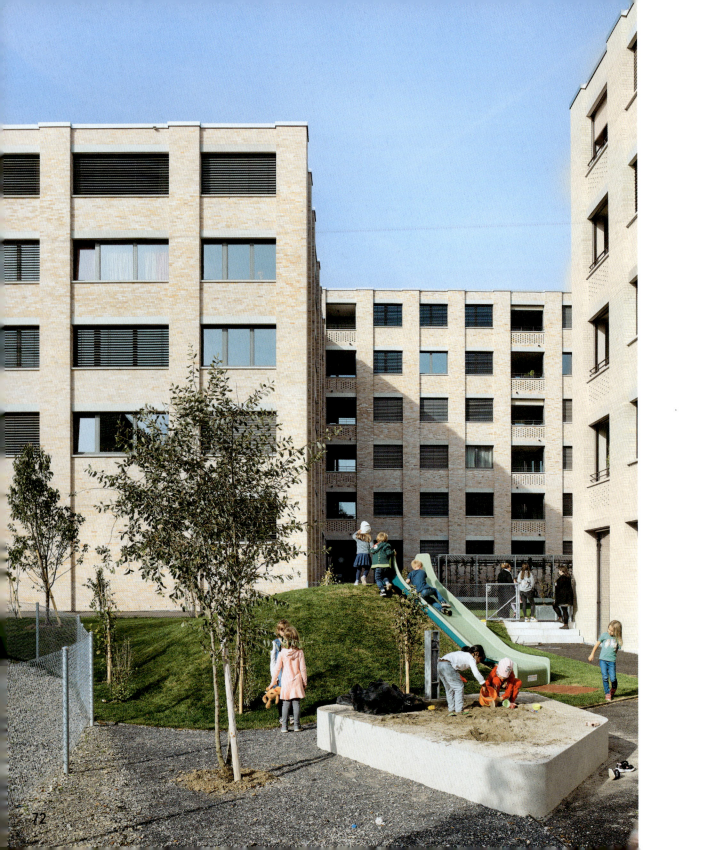

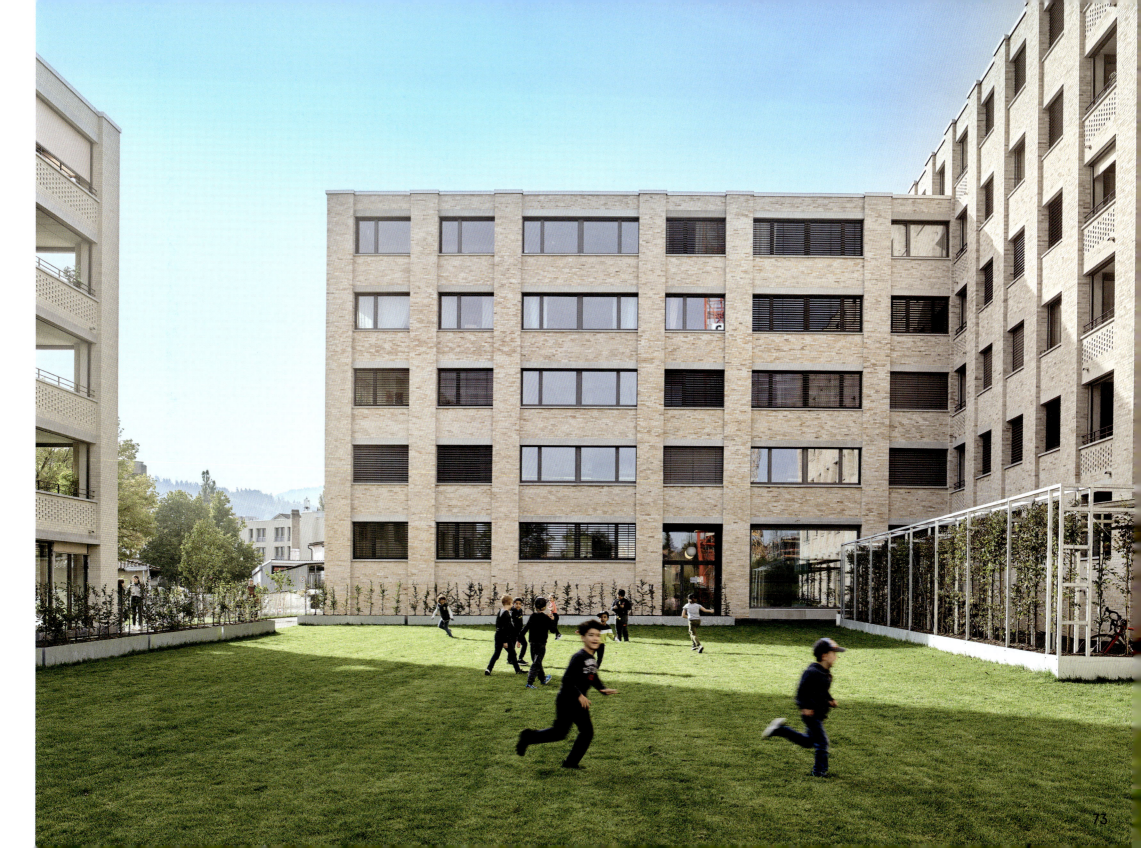

The new tenant Is that all? asked the landlady.
The new tenant looked up at the landlady, who was standing in front of him on the mezzanine, between the front door and the first-floor landing. She was tall, with big curls and big hands. She pulled a set of keys from her coat pocket.
He nodded and said that was all, and thought that underneath the landlady's curls there could be more heads.
It smelled of cold from the cellar and of cleaning products, lemon. And it was only then that he noticed there was a wolf howling on the landlady's pullover.
Nothing else? asked the landlady.
Nothing else, replied the new tenant, looking at his box, which was neither heavy nor light, which was just the right weight to carry easily in both hands.
The landlady moved aside and let the new tenant climb the stairs.
She stayed on his heels.
With a key from her set of keys, she unlocked the door.
Here we are, she said, and gestured into the narrow hallway with a sweep of her arm.
Once inside the new apartment, the new tenant set down the box. Something inside rattled softly.
The new tenant followed the landlady through one room, through the next, down the hallway, into the kitchen, a quick glance into the bathroom.
Are pets allowed? he asked.
The house rules forbid pets, has he not read the house rules? She glanced at the box.
Oh no, no, he hasn't got a pet. He just thought, maybe a cat one day, it doesn't have to be here, not now, so…
That's OK then, said the landlady, and she took a while to detach a small set of keys from the big set of keys and hand them to him.
She needed to go. Settle in and make yourself at home.
He'd start right away, said the new tenant, and closed the door behind the landlady.

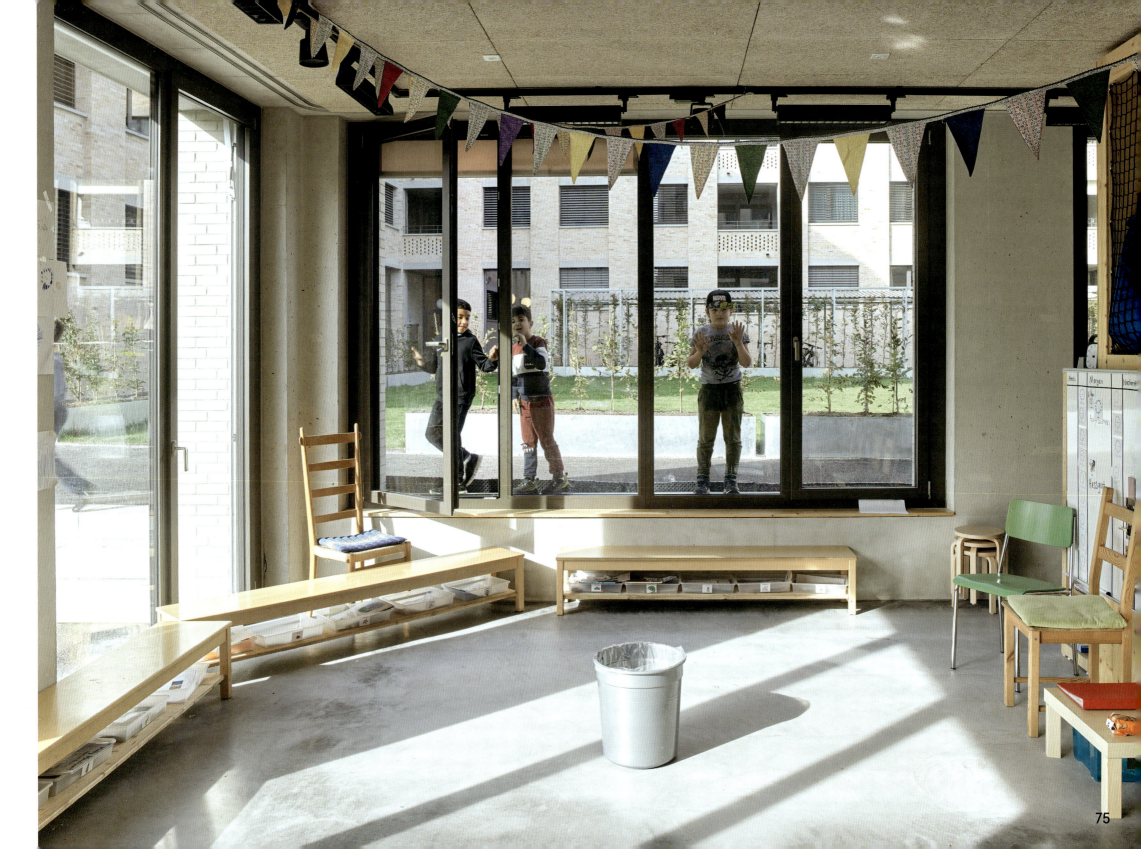

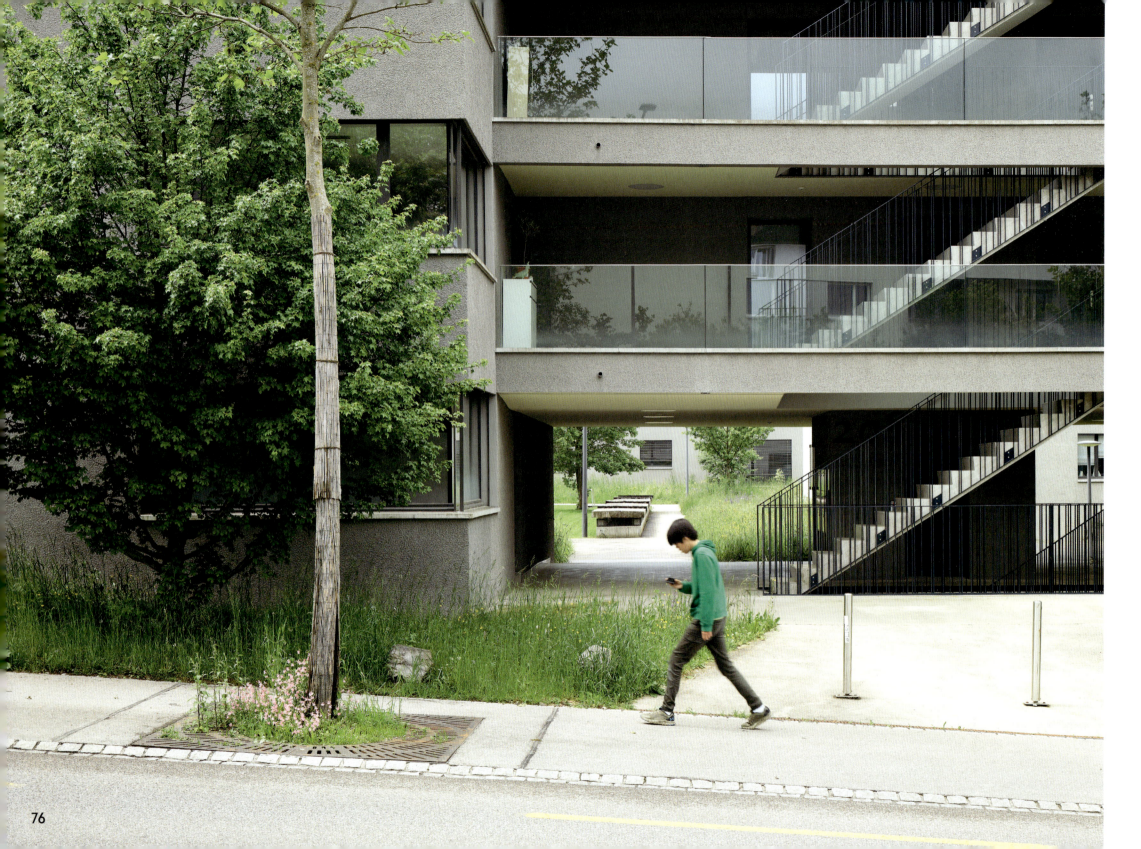

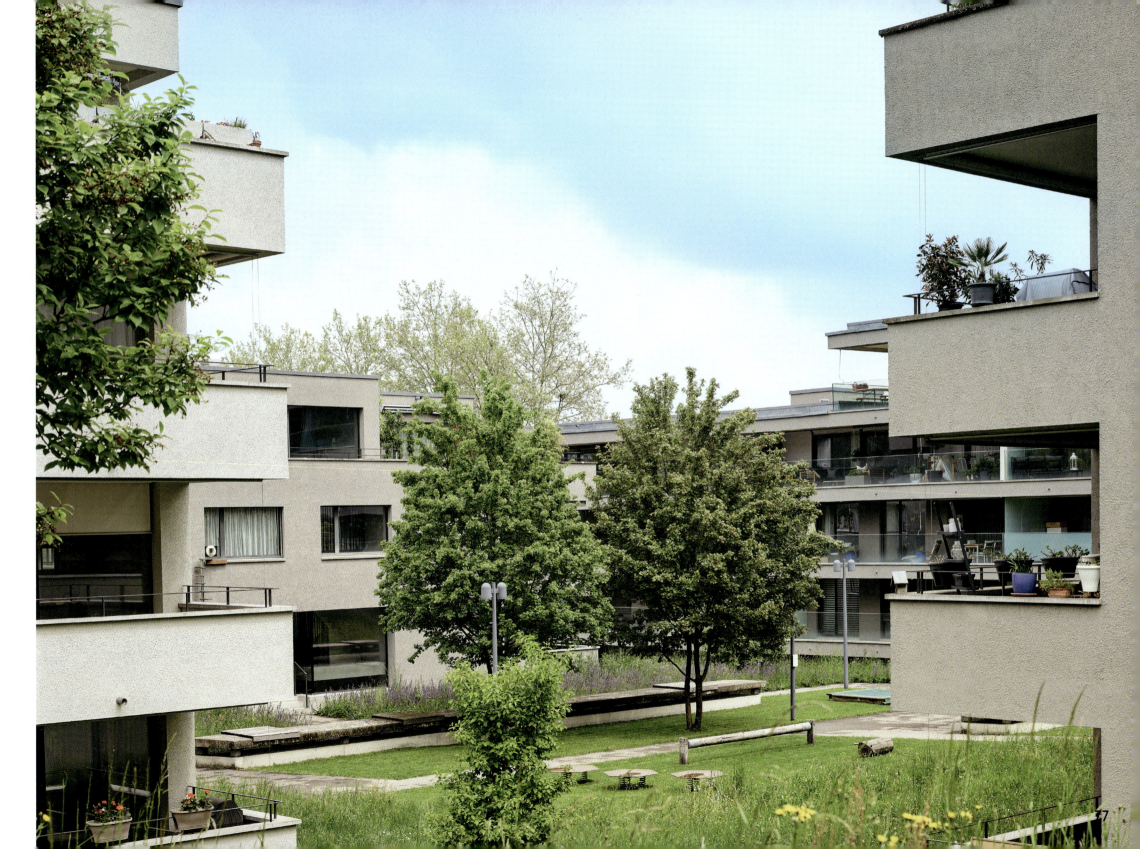

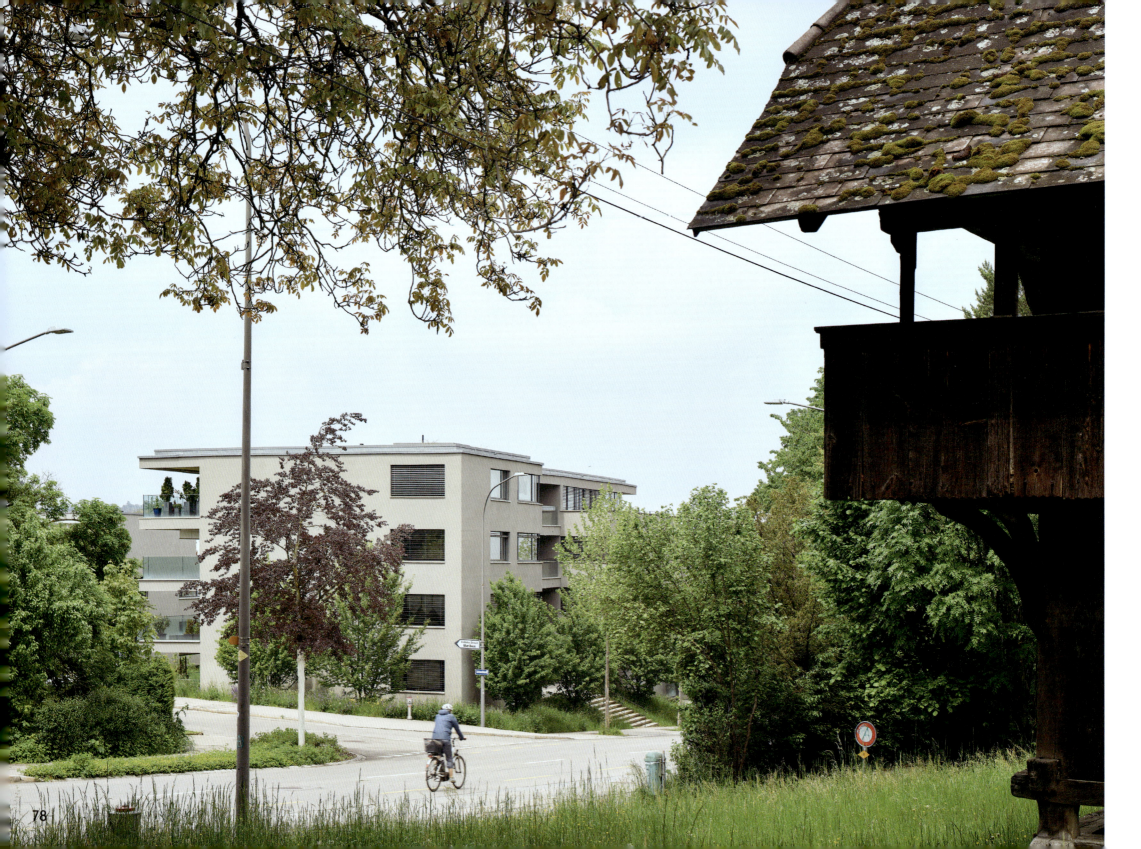

On the Worble The news team films the irate workforce, furious and its future tottering. The news team interviews the male workers, in the background more irate male workers, a few female workers, a Unia trade-union flag, geraniums on the windowsill.
They are growing increasingly angry, they say, not least because the management is only feeding them information bit by bit.
The news team zooms in with the camera on the buffet table laid with open-faced sandwiches, which the male workers and the few women workers are eating bit by bit. Each slice of bread is topped with a pale slice of tomato.
The news team films the interior of the factory, films a giant machine that lies in one corner like a sleeping dragon, not moving, not whirring, not rattling, not hissing.

Thirteen years later, excavators and concrete mixers are rumbling and construction is under way. Walls have been removed and walls are being erected, behind which in the future there will also be machines – much smaller machines – that whirr, and perhaps hum: coffee machines, washing machines, refrigerators, dishwashers. In the future the space will be converted, an art college will move in, with 45 workrooms, 10 workshops and 1,221 tables.

This is a good location, says the regional development officer. You won't find that written down anywhere, it's written in the buildings themselves, he says, tapping one of the walls with the tip of his pencil.
Solid, says the journalist.
For heaven's sake! says the regional development officer.

The Ice Age Rhône glacier and Aare-Glaciers once converged here. They melted out of the valley long ago, made their getaway. They left behind eye-catching hills.

Goosanders and grey herons also like the area, says the regional

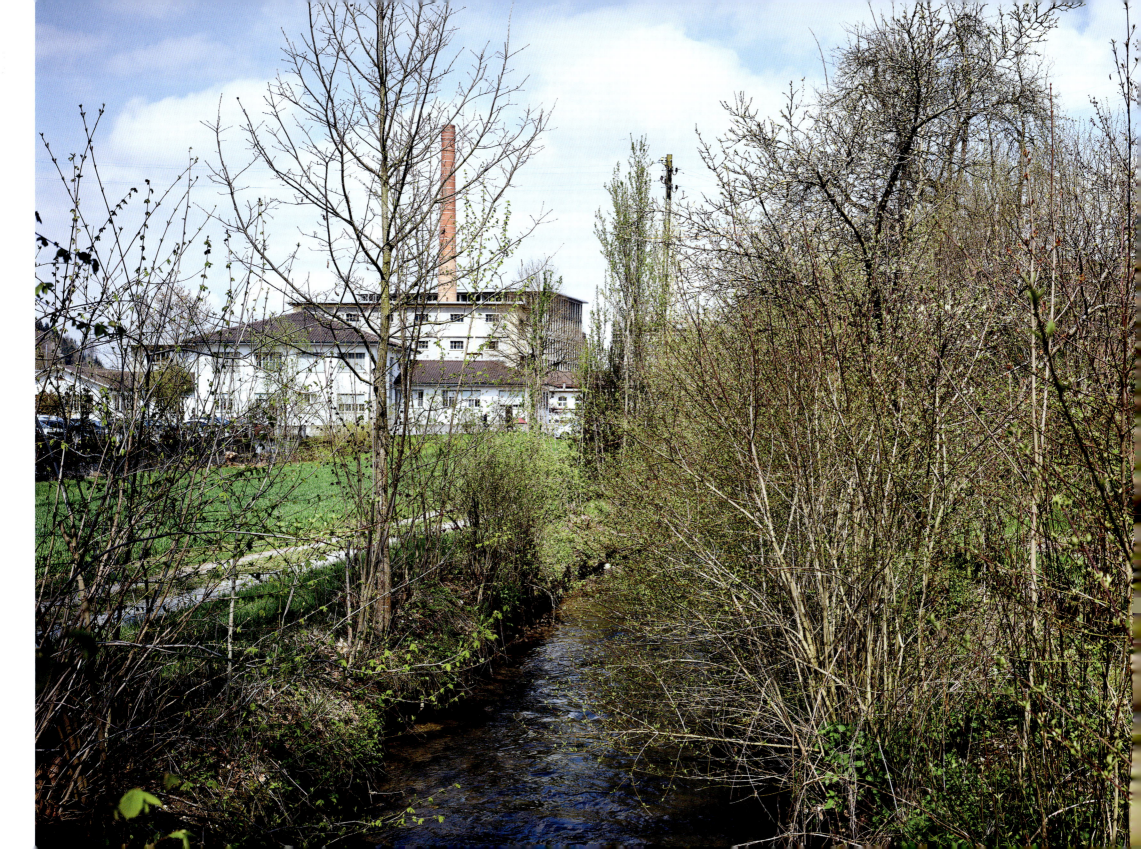

development officer, and points to the sky. Then he points to the river. It flows sedately, the Worble.

About 300 litres of Worble water were needed for one kilo of paper, says the regional development officer. And because the cardboard factory used so much water, the groundwater level in the surrounding area sank. Then, when the factory closed, the machines stopped and nothing stirred any more, the groundwater level began to rise again. The water pushed upwards, pushed from below, flooding the cellars of the houses that had been built in the meantime. And the steadily rising water had to be steadily pumped away. Even now, the regional development officer continues, it still needs pumping, pumping, for all eternity.

The journalist imagines the art college moving in; she imagines male workers, a few female workers in overalls, carrying removal boxes made of cardboard out of a truck into the buildings.
The factory building itself resembles a cardboard box, thinks the journalist. It lies nested. Shell constructions. Old halls.
And beneath it, the Worble whirls.

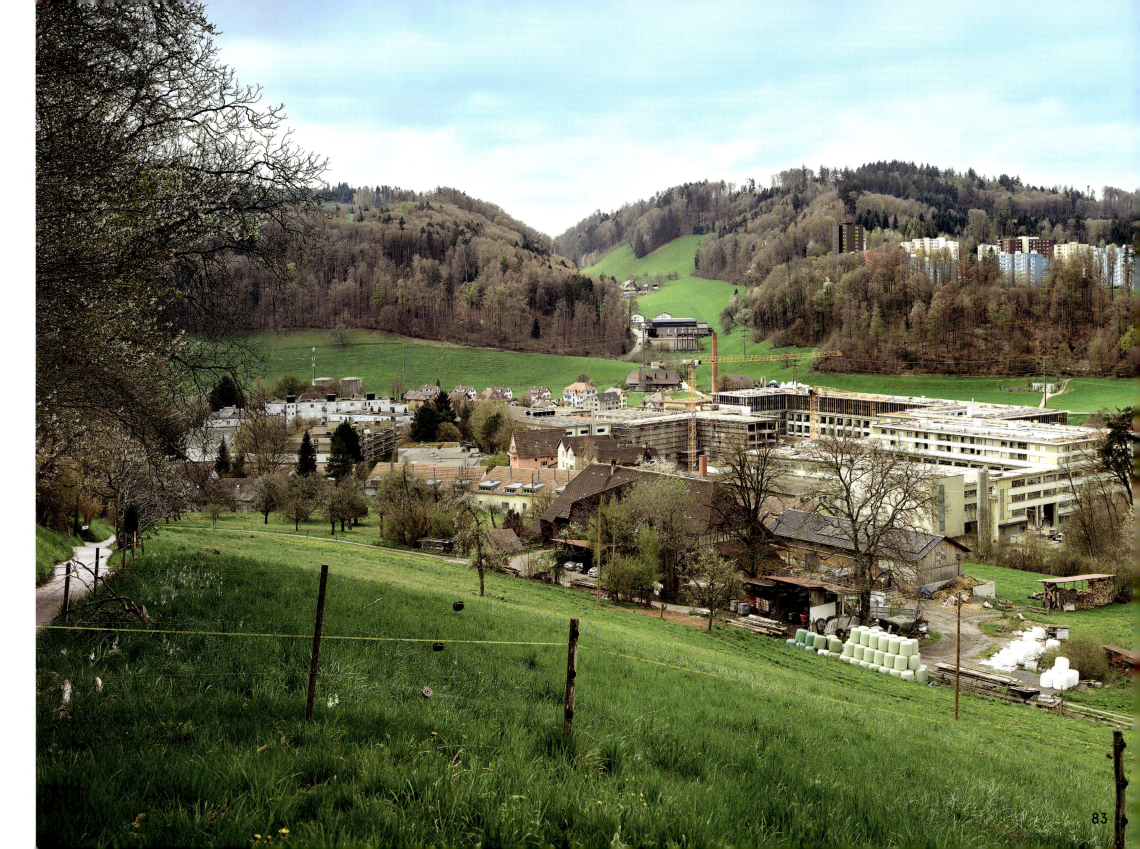

Piazza And on all the other benches in this square in spring are people biting into slices of pizza instead of arguing.
The oil seeps slowly; the cardboard drinks its fill. Every now and then, tomato sauce drips onto a trouser leg. Otherwise midday quiet.

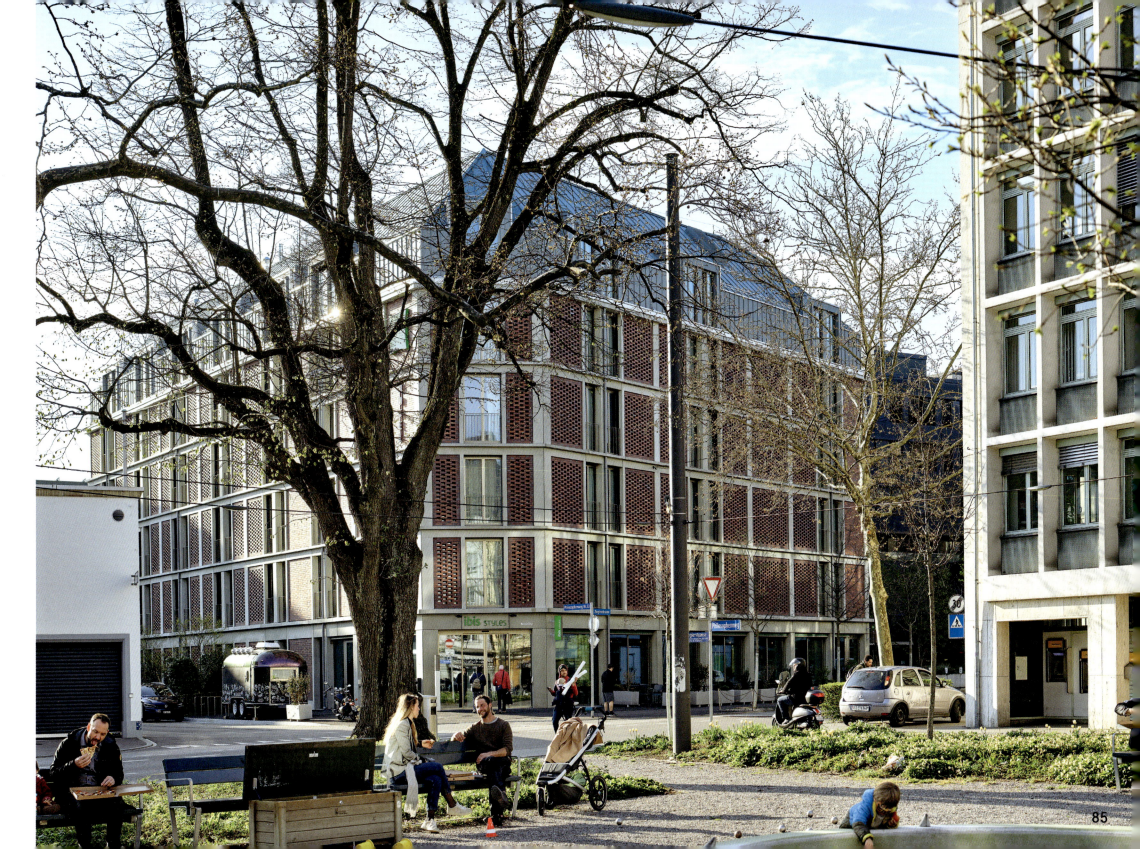

Ocean liner Mrs Lutz walks along the rounded corridor, the window façade on her right, her fingers closed around the handrail on her left. The rail stops only when a door comes along. She lets go and grips it again once past the door, her hand clenched.

Mrs Lutz blinks. Through the windows she recognises parts of sky and parts of trees and wind in the trees like waves. She walks past doors behind which babies once grew in incubators and babies yelled and now people put their aged legs up, and where there are wool blankets despite summer and cold hands on soft pillows.
In one of the rooms lives Mrs Lutz. A bed – the bed is on wheels and can be positioned wherever you choose – and a table, two chairs and a built-in cupboard. In the built-in cupboard, comfy clothes, one pair of terry pyjamas, one pair of silk pyjamas, wool socks.
Mrs Lutz opens a window, listens to the rolling waves.

She always sits in the same chair. Sometimes Ludo, the nurse, sits in the second chair and looks outside with her. And sometimes Mrs Lutz talks about travelling.

In the morning, she wakes up in another corner of the room.
The brakes must have come off, says Ludo.
Or did you move the bed yourself? Mrs Lutz?
The bed is now closer to the window.

Ludo brings the meal. Tomato soup, risotto, preserved pears.
The best for last, says Mrs Lutz.
I like preserved pears too, says Ludo.

Mrs Lutz walks down the corridor, across the raspberry-coloured linoleum, past the room occupied by Mrs Josch, who only moved in a week ago, who knows nothing yet of the rolling of the beds, of the play of shadow and light on the wall, of the crashing of the waves against the prow in a storm.

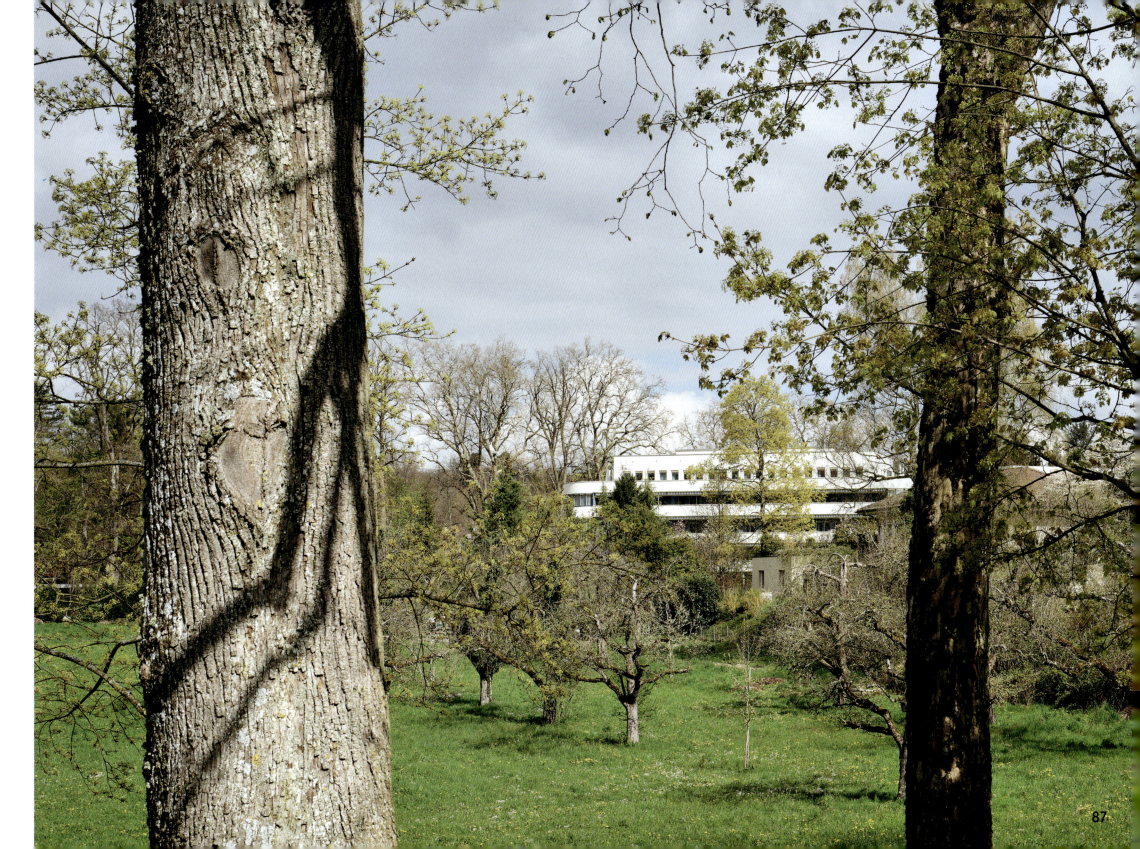

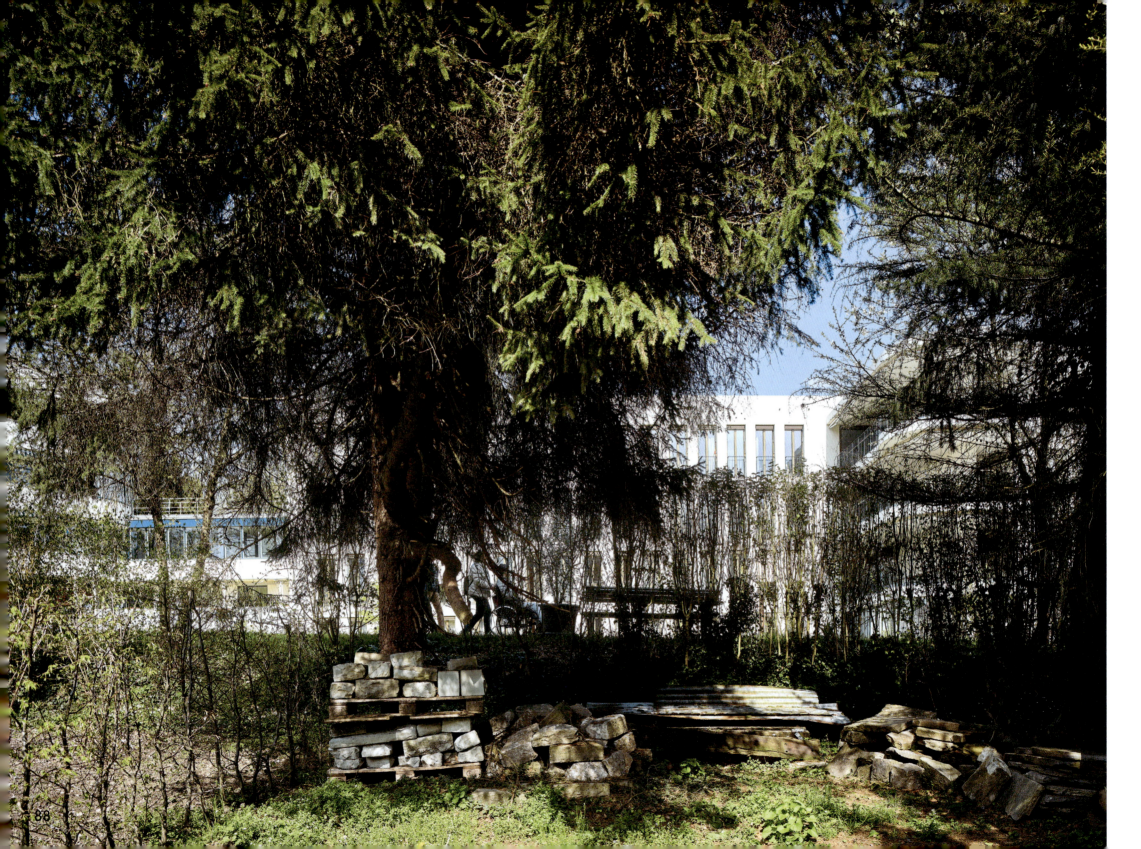

Mrs Lutz is lying on the sun deck, above her the whirring of the white-and-green roller blinds. And now there is sun on Mrs Lutz's face and beneath her closed eyelids it grows bright.

In the morning she wakes up once again in a different place, even closer to the window. From here she can see the horizon even better, see even better the wind in the trees like waves.
Mrs Lutz sees a seagull sitting on the terrace railings.
Mrs Lutz blinks.
The seagull stares.

Ludo is coming along the corridor when Mrs Lutz wakes up.
Mrs Lutz waves him over.
Have I overslept, am I late? Mrs Lutz asks.
Don't worry, you don't have any appointments today.
Ludo darts into the next room.

Time is not reliable. Entire days disappear.

In the Quiet Room, there is lapis lazuli on the ceiling and a large photograph of a tree hanging on the wall. Mrs Lutz has looked at the picture while passing by: the door was open.
A single leaf in flight.

While Mr Schuhmann surveys the half portion on his plate from all sides, Mr Keller pushes a fried potato from one edge of his plate to the other and Ludo removes a steamed tomato from Mrs Josch's plate, Mrs Lutz watches as bubbles of carbon dioxide rise in her glass of water.

Steel blue
Lime green
Pine green
Sienna red
Cadmium red
Sunny yellow.

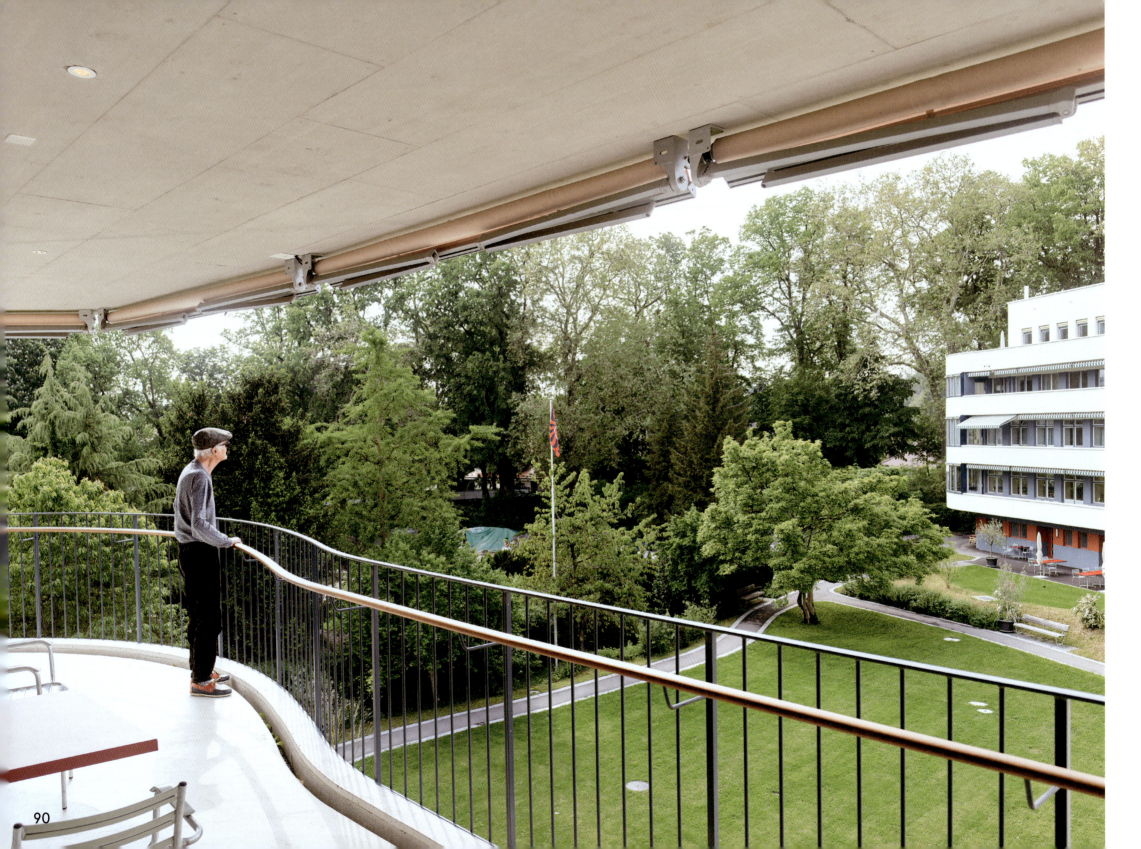

Mrs Lutz's hand is closed around the handrail. Her skin is fragile, rippled, undulating, with pigments, there paler, here darker. And in her hand the wood, which is smooth and even, which is dark. And her hand so pale.
Much too pale.

Mrs Lutz sits on the edge of the bed. The wind is still.
It has never been so still.
And then suddenly:
The ship's horn blares.
Ludo, come!
The window panes are shaking.
Not too late, then.
The liner sets sail.
Ocean ahead.

Railway station His gaze slides along the marble columns, which are now free of plaster and are gleaming. He sees the dark red bases of the columns, the newly laid slabs. The painter himself comes from Valais. He has travelled here not by train, but by car, and has spent countless hours in the station building, which is to be restored to its original state.
He has made colour samples, remixed them, tested them again, until the colours were right. Then the painter painted light green and light yellow and light blue on the stucco on the walls and ceilings, painted standing, kneeling, sitting, lying.
And now, standing beside the marble column, he looks into the station hall behind the building, looks up at the high truss ceiling, imagines the steam of the locomotives that once filled the halls, imagines old trunks and people with hats and a constant hissing and much shouting. And he sees the old platforms disappearing from the station hall, sees new station buildings growing, new platforms springing up, sees railway networks proliferating and travel itself changing. And the hands of the station clocks, too, are replaced with new ones that nevertheless steadily turn, showing the seconds that count and the missed minutes.
The station, when it is back in its original state, will enable the future to see a little bit of the past, thinks the painter, and wonders what the trains of the future will look like. Will they still run on rails? For what reasons will the travellers of the future travel?
The painter himself has no wish to travel. Wherever to? But he would like to look into this future. Would like to see what the travellers of the future will look like, what luggage they will have with them. What wishes and desires they will cherish and what cares and concerns they will face. And he wonders if there will be new colours in the future, quite impossible to imagine. And he tries to imagine these unimaginable new colours. And it makes him dizzy and he has to hold onto the marble column and focus on a rosette. Only for a moment. Just until the epochs and colours in his head have sorted themselves out again. Then he lets go of the column and drives back to Valais.

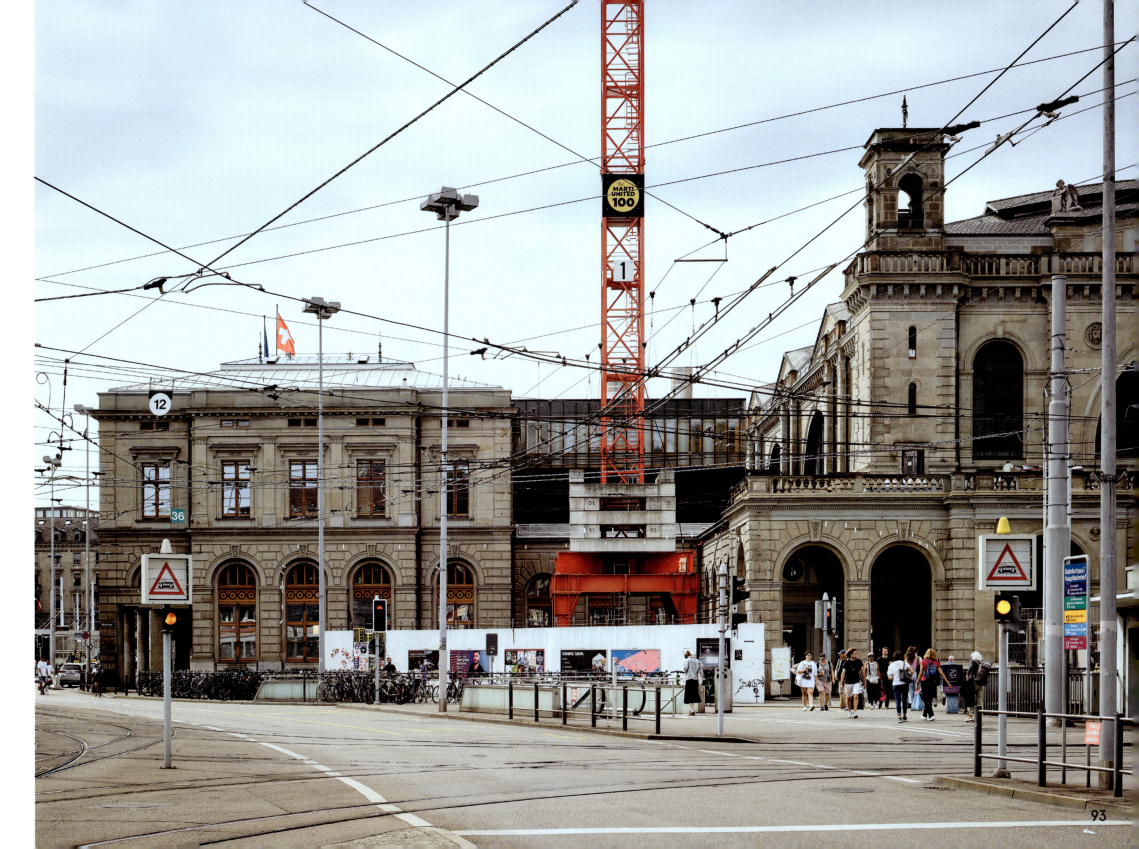

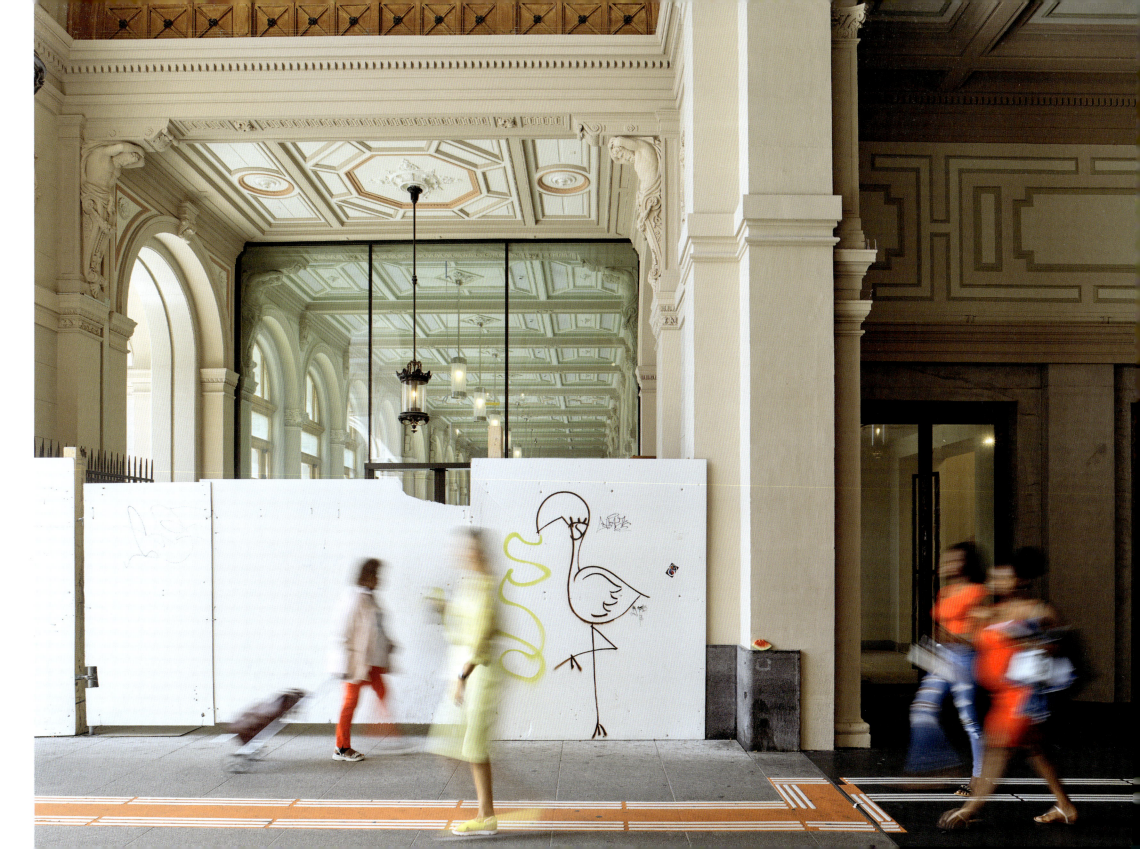

Afterthoughts

In Greek mythology, Hestia is the daughter of Kronos and Rhea and the goddess of the hearth – both the public and, most importantly, the domestic hearth. She is the symbol and assurance of tranquility, constancy and permanence. Hestia is often represented together with Hermes. But while it is true that he, too, likes visiting human homes, Hermes remains the most elusive of the gods: he stands for movement, change and transformation.

A similar antithesis is found in pre-Socratic philosophy, where it becomes existential. For Parmenides, being is balanced and self-contained. For Heraclitus, on the other hand, everything is in flux and all is fleeting and ambiguous.

The contradiction continues to exist for Socrates and Plato, but the two opposing positions are interwoven. Thinking as a philosopher, according to Socrates, means to avoid commonplaces, throw prejudices overboard and let go of supposed certainties. Only then does thinking become a creative instrument of knowledge. But thus the philosopher is always searching, always journeying, and never at home. Dwelling is peace and security; thinking is uncertainty and movement. The average person remains on the ground; the restless philosopher strives for higher things. The hearth is the prison of the mind. The home is incompatible with philosophy.

But is that really true? Philosophical thinking by no means signifies disorientedly wandering around the world. It represents the free, open, venturous but purposeful search for knowledge – a knowledge we carry within us, at least as an intuition, and which in general is simply buried. The hope of attaining this knowledge, the hope of wisdom, is also the hope of arriving and resting. Of dwelling. Of a house. Even philosophers find their home in the house of ideas.

This paradox is just one of many that appear in Socrates' teachings. Beyond the house as a metaphor for coming home, the paradox also applies to the house as object.

The purpose and aim of a house are first and foremost to protect the inhabitants from the inclemencies of nature, as well as from disagreeable or hostile fellow humans. A house is a place of safety and calm. At the same time, however, a house – a good house – is a place of knowledge and wisdom. It not only protects and soothes those living within its walls, but enriches and uplifts them. It is more than a lodging or shelter: it is a home where we can truly and completely find peace.

Above and beyond its pragmatic material function, in other words, a house is an artefact that stimulates thoughts and creates and reflects emotions. An artefact that not only has an affinity with its residents, but also with their guests and fellow humans. And – last but not least – with its surroundings, in both the narrower and broader sense. A house forges a relationship with nature: it protects itself and its occupants from nature, and at the same time embraces nature in order to become part of it. A house ages and weathers. It is repaired and remodelled and extended. At the end of its life, it may be partly or even entirely recycled. It lives with its inhabitants, but also with their – our – planet. It marks the presence of humankind without overshadowing other presences or indeed erasing them altogether.

A good house is both an object of daily use and a cultural product, an artefact and a natural element, a haven of tranquility and a place of inspiration. It resolves the contradiction between Hestia and Hermes. It is no coincidence that these two divinities, who like each other despite their differences, both enjoy being in human homes.

Vittorio Magnago Lampugnani

18 June 2023

[Cover]

House on Kupfergasse
1996
Kupfergasse 10
3653 Oberhofen
Heinz and Pat Meyer, Oberhofen

[3–7]

Choiseul Parc Residential Complex
2004
Chemin des Graviers, 1290 Versoix
Investeam Swiss SA, Geneva

[9–11]

Maison les Grèves
2008
1426 Corcelles-près-Concise
Benno Weber, Bern

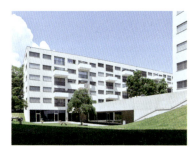

[13–15]

Labo Golette Residential Complex
2016
Rue de la Golette
1217 Meyrin
Fondation HBM Camille Martin,
Geneva

1st place, competition, 2005

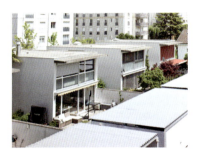 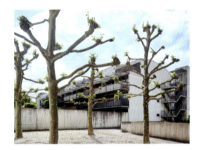 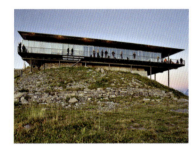 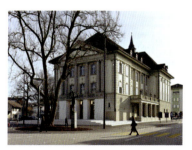

[16–19]

Grand-Saconnex Residential Complex
2000
Chemin Attenville
1218 Le Grand-Saconnex
Guy Vincent, Geneva

[21–23]

Troinex Residential Complex
1998
Chemin Dottrens
1276 Troinex
FMB – Fédération des métiers du bâtiment, Geneva

[24–31]

Berghaus Niesen (Niesen Alpine Lodge)
2002
Niesen Kulm
3711 Mülenen
Niesen Bahn AG, Mülenen

1st place, competition, 1998

Awards
'ATU PRIX', Bernese cultural award for architecture, technology and environment, 2003
'Neues Bauen in den Alpen' – architecture prize, 2006

[33–35]

Stadttheater Langenthal (Langenthal Municipal Theatre)
2017
Aarwangenstrasse 8
4900 Langenthal
Stadt Langenthal

1st place, competition, 2012

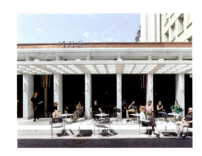

[37]

Restaurant Myle
2022
Bubenbergplatz 5
3011 Bern
Transa Backpacking AG, Zurich

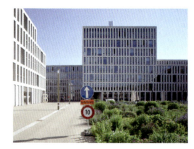

[39–43]

Administration Centre Guisanplatz
2026
Guisanplatz 1
3003 Bern
Federal Office for Buildings and
Logistics BBL, Bern

1st place, competition, 2013

Award
'Best Architects 20'

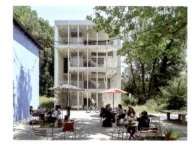

[45–47]

Youth Hostel
2016
Weihergasse 4
3005 Bern
Swiss Foundation for Social Tourism,
Zurich

1st place, competition, 2013

Award
'Best Architects 19'

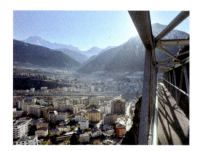

[49]

Master Plan, Municipality of Naters
2023
Gemeinde Naters
3904 Naters

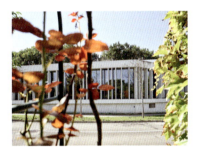

[52–53]

Rossfeld Residential School
2008
Reichenbachstrasse 122
3004 Bern
Foundation training and dormitories
Rossfeld, Bern

1st place, competition, 2006

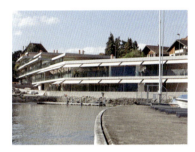

[55–59]

Wendelsee Residential Complex
2018
Staatsstrasse 26–30
3653 Oberhofen am Thunersee
apri ag, Baar

1st place, competition, 2006

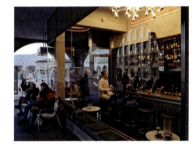

[60]

Asino il bar
2019
Casinoplatz 2
3011 Bern
Giolito AG, Bern

Awards
'Best Architects 21'
German Design Award, Special Mention, 2021

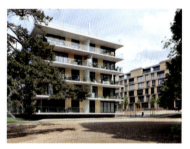

[63–65]

CIA Carouge Residential Complex
2009
Chemin de Pinchat 16
1227 Carouge
Caisse de Prévoyance du personnel enseignant, Geneva

1st place, competition, 2007

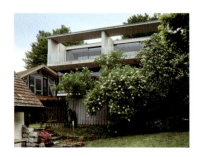 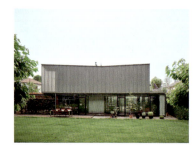 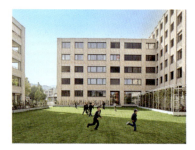 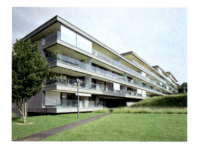

[67–68]

Bernstrasse Residential Complex
2009
Bernstrasse 15
3360 Herzogenbuchsee
Andreas Urwyler, Herzogenbuchsee

Award
The Daylight Award, 2011

[70–71]

House on Cuno-Amiet-Strasse
2004
Cuno-Amiet-Strasse 57
3360 Herzogenbuchsee
Peter Aebi, Herzogenbuchsee

[72–75]

flo&fleur Residential Complex
2026
Thomasweg
3097 Liebefeld
HIG Immobilien Anlage Stiftung, Zurich

1st place, competition, 2016

[76–78]

Hertenbrünnen Residential Complex
2014
Muhlernstrasse
3098 Schliern bei Köniz
Frutiger AG Generalunternehmung, Thun

1st place, competition, 2005

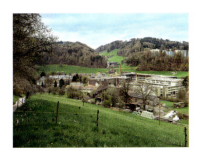 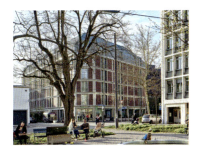 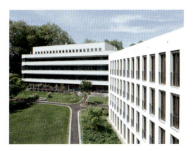 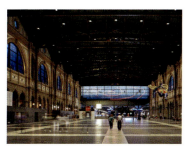

[81–83]

Bernapark (Park on the site of the former Deisswil cardboard factory)
2024
Bernstrasse 1
3066 Stettlen
Bernapark AG, Stettlen

[85]

Hotel Astoria
2022
Zieglerstrasse 66
3007 Bern
Boissée Finances SAS, Paris

[87–91]

tilia Elfenau Care Home
2019
Elfenauweg 68
3006 Bern
tilia Foundation for Long-Term Care, Ostermundigen

1st place, competition, 2010

[93–95]

Zurich Main Railway Station, South Wing
2023
Bahnhofplatz 15
8001 Zurich
SBB Immobilien AG, Zurich

1st place, competition, 2009

Imprint

The photographers thank Bernhard Aebi and Pascal Vincent for their generous support.

Concept: Adrian Scheidegger, sofies Kommunikationsdesign and Aebi & Vincent Architekten
Translations: Karen Williams
Copyediting: Colette Forder
Proofreading: Sarah Quigley
Project Manager: Verlag Scheidegger & Spiess, Chris Reding
Design: sofies Kommunikationsdesign AG, Zurich
Image processing, printing, and binding: SiZ Industria Grafica, Verona

© 2023 Aebi & Vincent Architekten, Adrian Scheidegger, Alexander Jaquemet and Verlag Scheidegger & Spiess AG, Zurich

© for the texts: Gianna Molinari and Vittorio Magnago Lampugnani
© for the images: Adrian Scheidegger and Alexander Jaquemet

Verlag Scheidegger & Spiess
Niederdorfstrasse 54
8001 Zurich
Switzerland
www.scheidegger-spiess.ch

Scheidegger & Spiess is being supported by the Federal Office of Culture with a general subsidy for the years 2021–2024.

All rights reserved; no part of this publication may be reproduced, stored in a retrieval system or transmitted in any form or by any means, electronic, mechanical, photocopying, recording, or otherwise, without the prior written consent of the publisher.

ISBN 978-3-03942-161-9

German edition: *VON HIER AUS* (ISBN 978-3-03942-160-2)